SUPERNATURAL
LORE OF
PENNSYLVANIA

SUPERNATURAL LORE OF PENNSYLVANIA

GHOSTS, MONSTERS AND MIRACLES

EDITED BY THOMAS WHITE

THE
History
PRESS

Published by The History Press
Charleston, SC 29403
www.historypress.net

Back cover, top: Autumn colors at Dingmans Creek, Delaware Water Gap National
Recreation Area, Pike County, Pennsylvania. *Copyright 2010 Jennifer Lehman, SunnyDazzled.*

First published 2014

Manufactured in the United States

978.1.62619.498.4

Library of Congress Cataloging-in-Publication Data

White, Thomas.
Supernatural lore of Pennsylvania : ghosts, monsters and miracles / Thomas White.
pages cm
ISBN 978-1-62619-498-4 (paperback)
1. Folklore--Pennsylvania. 2. Legends--Pennsylvania. 3. Tales--Pennsylvania. 4. Ghosts-
-Pennsylvania. 5. Pennsylvania--Social life and customs--Anecdotes. 6. Pennsylvania--
Biography--Anecdotes. I. Title.
GR110.P4W48 2014
398.209748--dc23
2014023435

In memory of Jean White and Anthony J. and Barbara C. Lavorgne

CONTENTS

ACKNOWLEDGEMENTS

I n many ways, preparing an edited volume can require more of an effort than writing a book as an individual author. I am grateful to all of the people who assisted me during this process, especially the contributors who shared their knowledge in their respective essays. Also, I want to thank my wife, Justina, and my children, Tom and Marisa, for their support and for allowing me the time to complete this project. I would like to thank my father, Tom, and my brother, Ed, and his wife, Heather, for their continued support as well. Numerous other people helped me and moved the project forward in a variety of ways. Tony Lavorgne, Gerard O'Neil, Zaina Boulos, Megan Defries, Michelle Bertoni and Elizabeth Williams all spent time proofreading and editing for me, and their help was greatly appreciated. A special thank you goes to Katherine Barbera, who was not only a contributor and a proofreader but was also my sounding board throughout the project. Her input and observations were vital and helped the process go smoothly.

The contributors would also like to thank the following people and organizations (in no particular order) that made this collection of writings possible. They include Rich Oswald, John Gishbaugher, Maddison McKeel, Jordyn McKeel, Mara Rooney, Haley Bristor, Brian and Terrie Seech, Mark Headings, the Green Mount Cemetery Board, the Cornerstone Genealogical Society, the Greene County Historical Society, Waynesburg University, the Bedford County Historical Society, Chris Bilardi, the Elizabeth Township Historical Society, Robert and Deborah Bertoni, Emma Rose Bertoni, Margaret McElroy, Christina Kubica, Joseph McAndrew, Andy Herrman,

John and Roseanne Williams, Andrew Williams, Karin Dillon, Dr. Joshua Forrest, Art Louderback, Kurt Wilson, Ken Whiteleather, Brett Cobbey, Dan Simkins, Brian Mckee, Brian and Jenny Hallam, Will and Missy Goodboy, Vince Grubb, Michael Hassett, Elisa Astorino, Rebecca Lostetter and Hannah Cassilly and the rest of the staff of The History Press.

INTRODUCTION

THE SUPERNATURAL IN PENNSYLVANIA

Supernatural belief systems provided order, purpose and meaning long before science defined the physical and intellectual boundaries of the world. They are one of the common threads that have linked together all cultures and peoples throughout history. Even in the modern world, dominated by science and technology, it can be argued that the presence of the supernatural in our culture is as strong as ever. One explanation for this apparent dichotomy lies in the fact that science, even though it can provide explanations for occurrences in the world and in our lives, cannot impart a greater meaning to them. By its very definition, the supernatural deals with forces that exist beyond science and the laws of nature. Supernatural beliefs provide an alternative to the cold, mechanical and often dehumanizing explanations of science. For believers, supernatural occurrences prove that there is something more.

Here in Pennsylvania, there is a long and vibrant history of supernatural folk beliefs and legends. For those who study the folklore and cultural history of the state, it is a seemingly bottomless well of material. Even though Pennsylvania has historically been at the cutting edge of political thought, freedom, industry and technology, it has also been at the crossroads of many folk traditions. Diverse religious, ethnic and cultural groups have populated the state since the time of William Penn. Economic opportunity also attracted various groups from both inside and outside the United States, and all brought their own beliefs. As the folklore of the various cultures slowly blended, new supernatural legends and tales were created while

people struggled to adapt to their new environments. Like other aspects of ethnic and religious culture, supernatural beliefs gave a feeling of stability in a changing world. They provided a sense of purpose, wonder and a framework of good and evil. They are also a vehicle with which to express hopes and fears, carry on traditions and remember the dead.

Pennsylvania's supernatural legends sprang from this fertile ground and continue to develop to this day. This volume provides just a sampling of the state's extensive supernatural lore. Those who contributed essays to this book are drawn from the ranks of historians, researchers, genealogists, ministers, skeptics, believers and practitioners. Their subjects are as diverse as ghosts, werewolves, lake monsters, prophetic dreams, miracles and folk magic. All of the essays have been arranged into three thematic categories—ghosts, monsters and miracles and magic. We hope that the varied perspectives of the writers will both entertain the reader and provide an appreciation of the depth, longevity and purposes of Pennsylvania's supernatural lore.

PART I

GHOSTS

The Restless Dead

Ghosts are history. Whether you believe in them or not, every time a ghost story is told, someone is providing an interpretation of events of the past. The details of a ghost story, aside from the phantom itself, may be factually accurate, or they may only be loosely based on actual occurrences. Either way, ghost stories are a memory of something real that had an impact on people and on the community—an accident, a disaster, a tragic separation, an untimely death, etc. This is, of course, not the type of history that is found in a textbook. Many of the events that are retold in ghost stories are not of national importance, but they are events that affected the lives of everyday people. Often, the people in such stories would remain obscure or forgotten if their supernatural tales were not told.

This is especially true for some groups of people who were underrepresented in traditional history before the second half of the twentieth century. As you will see, many of the ghost stories included in this section involve women who died in eras when their lives would be a mere footnote, if recorded at all, in histories of their day. Yet the stories of their lives and their tragic ends live on through their ghosts.

Ghost stories may also be repeated as a reminder of danger. Some ghosts are said to appear at bends in the road that have been the site of many

accidents. Others haunt dangerous industrial sites, where one mistake might mean injury or death. These kinds of ghost stories carry a warning along with history.

We may listen to, watch or read ghost stories for entertainment, because of an interest in the supernatural or because we have experienced hauntings ourselves. We usually do not actively think about the history and messages that they convey, but they are there nonetheless. Every ghost story has multiple levels of interpretation that are not exclusive, and the historical aspect is just one of these. At a different level, some ghost stories may record something truly supernatural. People have reported encounters with ghosts for thousands of years, and despite what many claim, as of yet, they cannot truly be scientifically proven or disproven. Perhaps it is better that way. It will be left for the reader to determine the veracity of the hauntings recorded here.

Our journey into the haunted history of the Keystone State will begin in Beaver County, where a headless ghost has wandered for two centuries.

THE PIG LADY OF CANNELTON

Thomas White

Sometimes her apparition appears with the head of a pig where her human head should be; sometimes it manifests with no head at all. For more than two centuries, the ghost of a young woman named Barbara Davidson has haunted the area around Cannelton Road in northern Beaver County. After she was murdered and decapitated, Barbara's head was never found; neither was her killer. Often referred to as the "Pig Lady," the phantom has allegedly appeared to and interacted with dozens of local residents over the years. Though many who live in the area are reticent to talk about their personal experiences with the ghost, the Pig Lady has been the subject of a local play, and she was even the inspiration for a local Halloween attraction. Her tale is not as widely known as some other regional hauntings, but it has proven to be one of the most enduring and fascinating supernatural legends in western Pennsylvania.

Much of the actual history behind the legend has been compiled and documented by former teacher Rich Oswald, who is a school director in Blackhawk School District and a local historian. Oswald became interested in the Pig Lady through the accounts of personal encounters passed on by his students. He came up with the idea of putting on a play every other year at the middle school to tell the story of Barbara Davidson, recounting local history in the process. The play has gone through several changes as new material has been uncovered, but it has remained a local tradition. Mr.

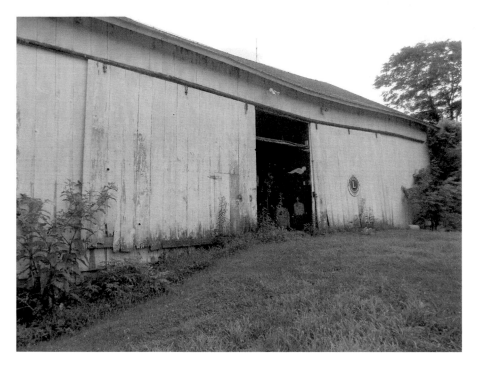

The "Haunted Barn" on Cannelton Road where volunteers reenact the true story of Barbara Davidson and the legend of her headless ghost every year around Halloween. *Editor's collection.*

Oswald was gracious enough to share his research with me as I began to look into the legend.

The story of Barbara Davidson begins around the start of the American Revolution. She was born in South Carolina in 1777, the daughter of rice planter Samuel McCaskey. Samuel fought on the side of the rebels and was driven off his property when the British invaded. After the war, McCaskey decided to relocate his family to present-day Darlington Township in Beaver County. At that time, it was part of the Depreciation Lands, which were tracts of land on the frontier that were offered cheaply to veterans of the Revolution. It was the new American government's attempt to compensate veterans for the almost worthless continental money with which they had been paid. McCaskey's tract was near the Little Beaver River and present-day Cannelton Road.

Barbara grew up on the family farmland, helping with chores and tending to the pigs and other livestock. She was a very open and sociable young lady, liked by all of her Scotch-Irish neighbors. Her beautiful voice and

musical talent were well known in the community, though she remained something of a tomboy and was a good shot with a rifle. Many suitors were attracted to Barbara, and in 1791, at the age of fifteen, she married an army veteran named Nathan Davidson. Marriage at such a young age was common at the time, especially if the husband was well established. Davidson lived in Virginia, so Barbara went to live with him there.

We do not know exactly what happened to Nathan, or if the two had a falling out, but by 1794, Barbara had returned to live with her parents in Beaver County. She resumed her work on the farm, and everything seemed to return to normal. The following summer, in 1795, her parents and the rest of the family made a trip to Pittsburgh for a few days to purchase livestock and poultry. Barbara was left behind to tend the farm in their absence. Samuel and Cora McCaskey would never see their daughter's face again.

When the family returned, Barbara was nowhere to be found. After several hours, it was clear that something was very wrong. All of the McCaskeys' neighbors joined in the search, but they found no trace of her. After several days, the family made a horrific discovery. Barbara's contorted body had been jammed into a crawlspace under their house. The beautiful young woman had been decapitated, and her head was missing. She was buried in the cemetery about two miles from her home. Her tombstone, which is now gone, was made of wood. The inscription read:

Barbara Davidson
b. Ap 11 1777 d. July 22 1795
A headless form neath this molde doth lie
Murdered most foul
Loved by all…save one

Despite their best efforts, friends, family and the authorities were never able to find or identify her killer. Her death shattered the peace and tranquility of the community. But that was not all. According to dozens of witnesses over the past two hundred years, the shocking and untimely death left Barbara unable to rest. Her headless ghost wanders the old family property and the area around Cannelton Road, seeking vengeance on her killer.

Over the years, many residents have only told of their experiences with Barbra's ghost anonymously, fearing public mockery or derision. Yet their large numbers speak volumes about the legend. The earliest accounts appeared around 1800, and they continue to this day. Barbara's ghost has appeared in different ways at different times and has wandered in an area

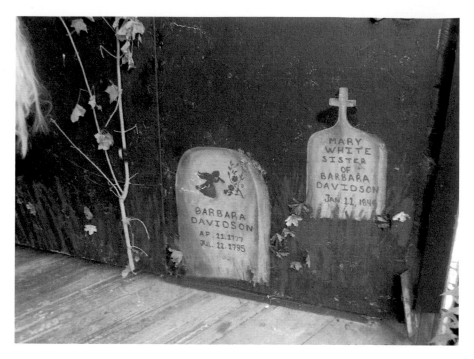

A depiction of Barbara Davidson's grave painted on the inside wall of the barn. *Editor's collection.*

covering at least a square mile. Frequently locals report that her shape first forms slowly out of a column of mist and fog, gradually taking the shape of her headless body. The ghost walks the woods surrounding her old home and the grounds of the cemetery where she was buried. Those who see her are insistent that the apparition moves like a young woman, her arms even stroking hair on a head that isn't there. On some occasions, the ghost has been heard sobbing, whether visible or not.

The story of the ghost was so well known that in 1935, the financially struggling Negley Traction Company tried to use the legend to make some extra money. It offered a tour called "Barbara Davidson's Midnight Excursion," charging fifty cents a head to ride the trolley out to the graveyard and past some of the locations where the ghost had allegedly appeared. Forty-three people participated in the tour, and they were not disappointed. The trolley arrived in the evening and parked for several hours while passengers anxiously looked around for any sign of Barbara. After some time, her headless apparition began to form out of the mist and moved across the property near the Fennel House. It came close

enough to the trolley to convince the passengers that it was not a trick perpetrated by the company, and many could hear sobbing and cries in the distance. The ghost was visible for almost fifteen minutes, and after the trip, everyone onboard was convinced that something strange had really happened.

It was not only Barbara's headless body that was appearing, however. There are several accounts of individuals encountering her spectral head. Because Barbara's head was never found, there has always been speculation as to its fate. Some people believe it was tossed into an old mine on the hillside above Cannelton. The mine sat along the side of the road that leads up to the Evergreen Orchards. Over the years, there have been reports of the ghostly head emerging from the mine entrance at night and frightening those who travel down the road at a late hour. Rich Oswald recounted one of the most dramatic encounters from over a century ago. Details of the incident were first recorded by Ira Mansfield in the book *Recollections of Life Along the Little Beaver Creek*, though many versions have been told over the years. It happened late one night when a man named either Bertram Drummond or Dick Gray (depending on the version) was bringing a wagonload full of freshly picked apples down the hill. Drummond/Gray was proceeding slowly down the dark road, with only one kerosene lantern and a little moonlight to guide him. As he passed the mineshaft, he was startled by a ball of light that emerged and streaked directly toward his wagon. The glowing shape seemed to attach itself to his lead horse, spooking the animal. As Drummond/Gray realized the light actually had long hair dangling behind it, the head turned and faced him. He was terrified by its burning red eyes. In a state of panic, he whipped his horses so they could escape. The ghostly head tormented the horse as the wagon sped recklessly down the road. Apples flew from the cart at every bump, and the horses did not stop until they reached the bank of the Little Beaver River. The spectral head finally abandoned the horse and disappeared in the direction of the mine. Drummond/Gray never took the road at night again.

The strangest part of the legend of Barbara Davidson is the alleged manifestation of her ghost with the head of a pig in place of her missing human head. Oswald believes that this part of the legend probably emerged in the twentieth century as teenagers went looking for the ghost. Stories are told of young people seeing a strange woman in the distance, but when they approach, she turns and reveals the grinning face of a pig. Sometimes the apparition is accompanied by a grunting sound, such as a pig might make.

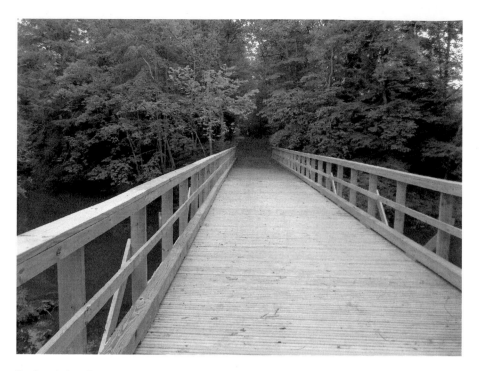

Barbara's headless ghost has been seen near the "Hippie Bridge" that crosses the north fork of the Little Beaver River. *Editor's collection.*

The Pig Lady has been spotted all around the Cannelton area, including the wooden footbridge over the north fork of the Little Beaver River, referred to locally as the "Hippie Bridge." While recording stories of these alleged encounters, Oswald discovered two theories as to why Barbara's ghost would appear with the head of a pig. One postulates that since Barbara raised livestock and took care of the pigs on her parent's farm, she selected the "replacement head" of an animal she had worked closely with. A second theory speculates that her ghost wandered for a long time in search of a head. Eventually, she encountered either the severed head of a slaughtered pig or the head of a dead wild pig and chose it to replace her own. The story of the pig head has become so popular that Barbara's ghost is often referred to only as the Pig Lady.

Supernatural encounters with the Pig Lady have not slowed in recent years. In fact, a recent community effort may have actually increased the number of encounters. In 2010, the Little Beaver Lions Club was looking to open a haunted house and hayride to raise money to help the blind and other people with disabilities. Dave O'Neill, then vice-president of the

club, suggested basing the haunted attraction on the real story of Barbara Davidson. Though O'Neill unfortunately did not live to see his idea come to fruition, John Gishbaugher and others transformed a barn along Cannelton Road (which was donated by Brian McCarl) into a recreation of the legend. The accompanying hayride took visitors through the fields to places where the ghost of the Pig Lady allegedly appeared. Volunteers played the roles of the various characters in the legend. Many of these volunteers began to have their own experiences with Barbara's ghost while they were attempting to tell her story.

One of those who encountered something otherworldly was Maddison McKeel, who has played the role of Barbara in recent years and other roles in the past. During her first year at the barn, while alone in the room that depicted the murder scene, Maddison turned to see the shape of a headless woman in a black dress. She immediately went to get another volunteer, but when she returned, the figure was gone. A more frightening experience occurred when she was crossing the field behind the barn. Numerous strange lights and shadowy figures have been seen in the fields over the past few years. One evening in her second year at the barn, Maddison was cutting through the field to check the location of other volunteers. Partway through her walk, she felt as if someone had kicked the back of her knees. She fell to the ground and hit her head, briefly losing consciousness. When she came to, she realized that she was in a different part of the field than where she had fallen.

Even before she had become involved with the haunted attraction, Maddison had a few supernatural experiences in the area. On one occasion, she was climbing a nearby hill toward a spring when she felt someone pull on the back of her shirt. When she turned to tell the friend that was with her to let go, she realized that she was too far away to have touched her. Maddison then turned around to see the fading image of a woman at the top of the hill. Another time, she was with a friend in the same woods when the pair spotted a set of glowing red eyes. They had heard the story that the eyes were those of Barbara's killer, and that if you stared too long, he might possess you. They both fled quickly.

Other volunteers at the site have also had experiences. Mara Rooney and several other volunteers parked their cars near the barn and walked to the nearby White Cemetery to look around. When they returned, one of the young men found that all of the doors on his truck were open, even though it had been locked and he had the key. Shadowy figures also followed Mara and Maddison once when they were crossing the field, and

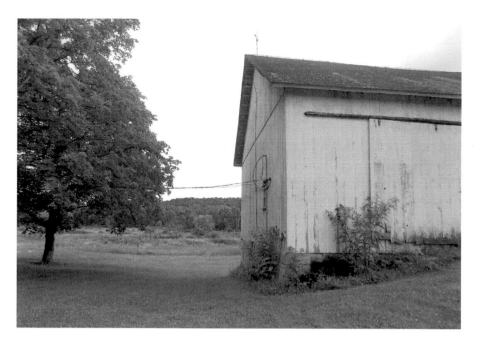

The side of the "Haunted Barn" and the fields behind it where Barbara Davidson's ghost has been seen and heard. *Editor's collection.*

A grassy area along the path of the haunted hayride where the ghost of Barbara Davidson materialized out of campfire smoke and spoke to a volunteer. *Editor's collection.*

Mara had seen a strange fog follow other volunteers around the property on several occasions. Mara and her friends also ventured to the grave site of Barbara late one night. As her friends spread out with flashlights, Mara remained still. It was then she felt something grab her hip. Those who came with her were too far away to have touched her. The group left and returned to the barn. When a light was shone on Mara's hip, a red hand mark was plainly visible.

Other volunteers who wished not to be identified also witnessed strange happenings at the barn and in the surrounding fields. The headless form of Barbara has been seen crossing the fields holding a candle in her hand. Many have reported seeing the strange flashes of light in the fields and have had tools and other objects disappear in the barn only to reappear in other locations days or weeks later. One volunteer saw her apparition materialize out of campfire smoke. As he sat watching the fire, mist and smoke slowly gathered into the clearly identifiable form of a headless woman. The man could not believe what he was seeing, but things quickly became even stranger. A woman's voice quietly emerged from the ghostly form. It said, "Tell them re-no." The apparition then dissipated before the man's eyes. At first, the man was unsure of what the ghost meant by "re-no," but he eventually decided that the apparition was really saying the French name Renault, which has the same pronunciation. When Rich Oswald heard the story, he conducted some background research on possible local connections to the name. He discovered that a half-French and half-Indian trapper named Renault was residing in the area around the time of Barbara's death. The trapper had a bad reputation among the local farmers. Could it be that Barbara was trying to identify her killer from beyond the grave?

As of this writing, the Haunted Barn and Hayride continues to attract visitors at Halloween, and each year more people experience the supernatural in a place that blends entertainment and authentic legend. The existence of the haunted attraction has brought more attention from outside the local area, drawing ghost hunters and paranormal investigators. The once-localized legend is spreading rapidly, and it is unlikely that it will fade any time soon. Perhaps, at some level, that is entirely the point of the legend—to remember the brief life and tragic death of a young woman who might be forgotten under normal circumstances. Barbara's ghost, whether real or a trick of the imagination, carries the history of early Cannelton with it every time it appears.

SOURCES

McKeel, Jordyn. Interview with author, July 2013.

McKeel, Maddison. Interview with author, July 2013.

Oswald, Rich. "Barbara Davidson: A Local Legend of Beaver County." Unpublished manuscript, n.d.

———. Interview with author, July 2013.

Rooney, Mara. Interview with author, July 2013.

Woodall, Candy. "Haunted House a 'Crazy,' Perfect Memorial." *Pittsburgh Post-Gazette*, October 28, 2010.

THE GHOST OF BETTY KNOX

Tony Lavorgne

There is nothing more frustrating or sad than an unsolved missing persons case. Unexplained disappearances haunt our history, and clues fade with the passage of time, leaving only memories.

Such is the case with Betty Knox of Dunbar, Pennsylvania. Her story begins back in 1842 on the ridges of the Dunbar Mountains in Fayette County. There, on a rough farm at Kentuck Knob, Betty Knox was born. She was the only child her parents would have. Much like the difficult land they worked, farming life had many hardships. When sickness came, the isolated mountain families had few doctors to turn to, and those few had often received limited training. Not that a doctor could have helped the Knox family. Young Betty was only three years old when her mother died from consumption, which was virtually untreatable. Her father raised young Betty the best that he could in such a circumstance.

As time passed, Betty became a strong and skilled mountain farmer. She was said to be able to perform the work of any man, and her father relied on her to help with all of the tasks that were performed to make the farm run properly. Nineteenth-century farming life was difficult, to say the least. Young Betty was responsible for or assisted with clearing the land, plowing, planting, weeding and reaping. Between the larger tasks, she found time to raise livestock and cook.

It was said that Betty grew into a very beautiful young woman with long auburn hair, a fair complexion and blue eyes. One could imagine why she was often pursued by all of the young men who lived in the lonely hollows

around Kentuck Knob. Being both beautiful and skilled at farm work made her the desire of many. However, Betty resisted all of their advances and turned away potential suitors, waiting for someone she truly loved.

It was in her seventeenth year that a freak timber-cutting accident took the life of her father. The tragedy left Betty alone on the mountain, but farming was her life, and she would not abandon her parents' homestead. To supplement her meager income, Betty had to take on additional difficult work. She began to haul grain in a wagon pulled by her ox for other nearby farmers. The young woman drove her ox and the grain-filled wagon over the mountains to the gristmill in Ferguson Hollow. In the evening, she would return the flour to the farmers. The grueling trip was about twenty-five miles in total and would consume the entire day. Betty followed the same trail so many times that part of it is still visible today. Other evidence of her journey survives as well. Betty Knox Park exists in the State Game Lands, on a level piece of land she usually traversed near Dunbar Creek. Nearby is a spring where she frequently rested on her long journey. To make its clean water more accessible, she lined it with stones.

Betty did eventually encounter one man with whom she became enamored, but like many other things in her life, it was a situation that ended tragically. On one fall evening in 1862, during the Civil War, Betty came upon a wounded soldier on her return trip from the gristmill. The young man was said to have deserted the Union army and wandered north into Fayette County. He was seriously wounded and delirious with fever. Betty took pity on the soldier and took him back to her farm. Desertion was a serious charge, so she kept him hidden from any unknown visitors. As she nursed him back to health, Betty began to develop strong feelings for the young man. He remained with her for over a year, never fully recovering from his injuries. The harsh mountain winter did not help his situation, and eventually the young soldier succumbed to his wounds. Betty buried him near her father's grave on Kentuck Knob.

Following the death of the soldier, Betty resumed her daily trips over the mountains. Betty and her ox became quite well known among the people of the region in the coming years, especially during the harvest. Even though she was welcomed by all, she always kept a reserved distance. Her persistent and dedicated hard work had won her the respect of her neighbors. But this is where our story turns into a mystery for the ages. Sometime in 1878, Betty Knox's famous mill trips came to an abrupt end.

Betty Knox had vanished without a trace. The local farmers began to notice that the grain was piling up in the log barns. Neighbors assumed at

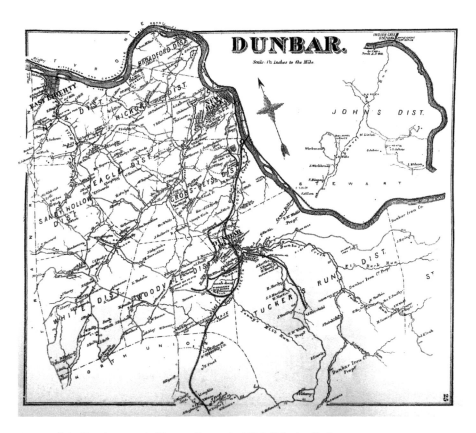

A map of the Dunbar area in Fayette County in 1872. *Editor's collection.*

first that she took ill. A small posse went to her farm, expecting to find her there in bed. To their surprise, she was nowhere to be found. A search party was then assembled to scour the nearby woods and her trail to the gristmill. Still, they had no clues as to her whereabouts. Among the locals, speculation grew as to her fate. Some thought she might have been attacked by a scorned lover or a wild animal and dragged off into the wilderness. Others guessed that she might have left willingly, out of loneliness. The mystery deepened the following spring when some children made a startling discovery while out in the woods. Chained to a tree, they found the skeleton of an ox. This was highly unusual because the spot had been searched thoroughly months before. No one reported seeing a chained ox, and Betty was never known to use a chain to lead her oxen. Whatever happened to the ox, many of the local farmers believed that the animal had belonged to Betty.

To this day, the case has never been resolved, and at this point, it is not likely that we will ever know what happened to her. That does not mean, however, that people have not continued to see Betty. It is frequently reported that her pale specter wanders her old trail, sometimes on foot and sometimes driving her ghostly ox and wagon. If Betty Knox herself is not seen, sometimes her creaking wagon and the hooves of her ox can be heard. The legend of her restless ghost has been passed on since her disappearance, and Betty Knox Park is frequently visited by those looking to interact with the ghost. Some visitors claim to hear not only her ghost, but perhaps that of her fallen soldier as well. Allegedly, if you stand by the crossing at Dunbar Creek on a dark night, you can sometimes hear a man whispering, "Betty Knox, Betty Knox." Does the ghost of this strong yet tragic woman still linger at the location of her unexplained demise? Or does the legend continue to be told simply to commemorate the life of this brave woman who might otherwise be forgotten in the pages of history? Maybe the legend is an attempt by the community to make sense out of Betty's mysterious disappearance by always having her "present" in the form of a ghost story. Perhaps it is all of these at the same time. Like the details of Betty's disappearance, we may never know for sure.

SOURCES

"Connellsville Ghost Stories—Legend of Betty Knox." http://connellsvilleghoststories.weebly.com/legend-of-betty-knox.html.

Ellis, Franklin. *History of Fayette County, Pennsylvania with Biographical Sketches of Many of Its Pioneers and Prominent Men.* Philadelphia, PA: L.H. Everts & Co, 1882.

"Pennsylvania Haunts and History: The Legend of Betty Knox." http://hauntsandhistory.blogspot.com/2010/04/legend-of-betty-knox.html.

SUPERNATURAL CEMETERY TALES

Robin Swope

As a pastor in need of a break from the mix of politics and religion, I took a sabbatical from denominational ministry for a few years in the late 1990s. During most of that time, I worked a very unique and inglorious job.

I was a gravedigger.

From 2000 to 2006, I worked at Erie County Memorial Gardens in Erie, Pennsylvania. It was part of a large conglomerate of cemeteries, with over one hundred located in Pennsylvania alone. Although I was employed in such a macabre arena, I personally did not have any experiences with ghosts or other creatures of the undead that we most associate with cemeteries. I did, however, hear all kinds of stories. Most of them concerned the strange goings-on in cemeteries in western Pennsylvania. Here are a few of the highlights.

This story took place just before I began work at the cemetery. Like many graveyards in the corporation, it had a large mausoleum on its grounds. On any given day during the winter, the first task at hand was snow removal, so the customers could visit their dear departed without bothering with snowdrifts.

One of the head maintenance men was clearing snow from the sidewalks and offices early in the morning one day in the middle of January. It was still dark, but the freshly fallen snow illuminated the landscape in an eerie glow. The maintenance man decided to save gas

and walk the quarter mile from the office building to start shoveling the snow around the mausoleum. Halfway there, he saw a figure walking behind the building. From the size, it looked like a child had just walked behind the mausoleum, but the worker could not be sure. It was a little odd but not entirely out of the ordinary that someone would take an early morning walk around the cemetery for exercise. But it was downright peculiar for someone to do it after a heavy snowstorm, let alone with a child. So, wearily, he surveyed the grounds for any sign of the child or parents who might be getting some brisk morning exercise.

But he saw no one as he neared the building.

He circled around to where he swore he saw the figure of the child, but there were no footprints in the snow.

As he looked up from the new snow, he saw a face peering from around the corner on the other side of the building, just fifty feet away from him. He could not make out features, but he saw the rough shading of eyes, mouth and nose from the shadowy figure that was examining him. It was about three feet tall, the size of a young child.

"Hey, what are you doing here?" he shouted and started to make his way through the drifts to the curious face. But as soon as he started to move, the head quickly disappeared from the corner. The maintenance man added some speed to his gait, but when he arrived at the corner, the child was gone. As he looked down to see where the young one had ran to, he once again saw no footprints.

Amazed and disturbed, he threw his shovel into the ground and mumbled to himself. He was sure someone was playing a trick on him, but he was clueless as to who it could be. For all he knew, he was alone in the seventy-acre cemetery—alone except for that small child who could disappear without leaving any tracks in the snow.

He shrugged and made a mental note to drill the other members of the crew when they came in to see if any one of them was up to shenanigans. If it were a trick, they would probably egg him on a while but then get their jollies at his expense. So, trying to push aside the oddness of the event, he went about shoveling the snow.

That was when he heard the voices.

At first, he thought it might be the wind. The mausoleum was out in an open field, and sometimes the wind whipped around the building fiercely and made all sorts of odd noises. But after a while, he knew it was not the wind. He heard the whispering voices even when the air was still. The whispering voices were barely audible, but to his ears, they were clearly distinct and

individual voices. It was as if there were a large group of people gathered together in the mausoleum having a conversation. He silently moved around the sidewalk to try to get a location for the voices. They seemed very close but at varying distances. It was as if many people were having a whispered conversation from a distance. Suddenly one of the voices seemed to be a little closer, and his heart almost stopped when he realized where they were coming from.

The voices were coming from inside the crypts in the mausoleum walls.

Frozen in fear, he thought he was going insane, so he slowly moved closer to the cold, ice-layered marble slab. The icy slabs concealed the cement crypts that made up the inner and outer walls of the building. As he put his ear to the freezing stone, he heard a distinctive whispering voice say, "Shhh! He hears us!"

In an instant, he dropped the shovel from his hands and ran to the office building. He never heard the voices again, but he vowed to never shovel the snow around the mausoleum in the dark ever again, either.

However, that was not the end of caretakers and others seeing shadow people in the early hours on the cemetery grounds.

One morning, I had come in early to get ready for a trip to a neighboring cemetery that needed some help because someone had called in sick. The sun was just about to rise, and the supervisor and I were sitting at a desk drinking some coffee and discussing current events when an elderly lady came to the office door. She seemed quite distressed.

She was barely able to get inside and was hanging on to the front door as if it were a lifeline. She must have been in her early eighties and almost collapsed just as my supervisor caught her and helped her to a seat.

The woman had visited her deceased husband's grave to put out a fresh flower arrangement before she went to an early-morning breakfast appointment with some friends. She was sitting on a blanket and arranging the flowers in the vase as the morning sun was just rising. While she was taking in the bright sunrise, she saw a figure move to her right. It was a lady dressed in a long black shawl, about forty yards away from her on the other side of the garden where her husband was buried. She saw no distinct features, but from the silhouette in the sunrise, she could tell it was a woman with a lithe figure who was standing erect with her head tilted down to the grave that she was standing over. The woman wondered who she was, because she had not seen her before as she had walked back and forth from her car to bring the flowers and water to her husband's grave site. In fact, she had been fairly certain that she was the only one in the area.

She was considering these things as the sun rose over the treetops to the east and the rays of light began to filter into the garden with intensity. The figure seemed to fade a bit.

Then it slowly sunk into the ground. It was as if the earth sucked up the silhouette of the woman and ate her.

We calmed the woman down and gave her some water. I went out to investigate and found her small blanket at the foot of the grave and the fresh flowers arranged in the vase just as she said. But I saw no other person on the grounds. A few minutes later, my supervisor came out with the woman, and we asked her where she saw the figure. I walked out to the opposite side where she gestured but saw nothing out of the ordinary. So I called to her to have me move where she thought she saw the figure vanish into the ground. When she had finished directing me, I looked down. I was standing over the grave of a young teenage boy who had shot himself earlier during the year with his father's gun. He had been an honor student with a bright future to look forward to. Then a random school drug search found a few ounces of cocaine in his locker. He was kicked out of school and faced serious charges. Instead of facing a bleak future, he chose to take his own life.

But the family tragedy did not stop there. Within a few months, the father had gunned down the boy's mother and a coworker with whom he had suspected her of having an affair. Then he put a bullet into his own head as well, just as his son had done just a few months earlier. The graves were all together. Father, mother and son slept together for eternity.

But according to the woman, something had visited the son early in the morning's twilight. Was it the mother? A figment of her imagination? Or just an illusion of the diffused lighting coming through the pine trees in the east? Or was it a dark entity that had influenced the family to commit such tragic and needlessly violent acts that still lurks at the grave site?

I have no idea. All I could do was pray that God would have mercy on their souls and grant them peace.

There were other stories that were more dramatic than chasing shadows and spectral voices. One of the most disturbing stories that I heard involved a wandering corpse that some of the workers called the "Mold Man."

In the late 1970s, a cemetery near Pittsburgh had built a new mausoleum. It had been promised for years, and the salesmen, eager to make a lucrative commission, had pre-sold crypts long before they were available. Many makeshift, cement, aboveground crypts were quickly built for those who had purchased mausoleum spaces and had passed on before they were built.

When the mausoleum was finished, it was the job of the gravediggers to disinter the bodies and place them in their new crypts. It was a disgusting and dirty job, for many of the caskets leaked the liquefied remains of the deceased.

To make matters worse for the gravediggers, everybody had to be physically identified by a mortician who had originally embalmed the body, and clothing or jewelry was noted to make sure the corpse in the casket was the person named on the makeshift crypt.

The supervisor remembered each decaying face, for they were burned in his memory, but one stood out. Most of the bodies had long since dried up and became desiccated. If any flesh was left, it was almost tanned leather hanging off the bony skeleton. Some looked as if they were made out of Jello, as the corpse had decomposed into a liquid goo. But one was odd.

When they opened the coffin of the old man, it was like he had just been laid to rest, except for one disturbing and obvious fact: he was covered with a furry gray-green fungus. All of his flesh had been eaten by the fungus, but it held the shape of his face so well that it shocked the superintendent and the undertaker. Except for the odd color and the fleece-like look of his skin, he looked like he might just open his eyes or mouth at any moment. They quickly got over the initial shock and noted that yes, he was who he was supposed to be and put the coffin in the second level in the back of the newly constructed mausoleum.

On Monday morning, when the maintenance crew came to open up the office, they noticed the mausoleum door was open. As they neared the open door, they immediately knew something was wrong. Something was smeared on the glass door of the mausoleum, and as they looked inside, one of the crypts was open.

And it was empty.

Fearing they had been targeted by grave robbers, they went to call the police. As they rounded the corner to head back to the office they passed the old makeshift cement crypts.

One was open, and it held a casket.

It was the casket of the Mold Man, right back in the place he had been interred for the last five years. To be sure everything was all right and they did not have a grave robber playing a joke, they opened up the coffin. The body was still there, and the jewelry he wore was still intact. They called the police, but there was nothing they could do but file a vandalism report. The body was placed back in the mausoleum.

After they sealed up the crypt again, the staff noticed that the smear on the door was the same color as the mold that covered the man. Another

disturbing detail was that there seemed to be small pieces of the stuff on the carpet that covered the floor from the crypt to the doorway. The body did not look molested at all, and the casket had shown no visible signs of forced opening, but it was still very troubling.

Two weeks later, it happened again. Everything was the same: the crypt was opened, and the casket was found resting in its old spot. Even the smear and pieces of mold scattered here and there was the same. But one thing was different this time. It had recently rained, and the ground was soft. A single trail of footprints ran from the mausoleum to the makeshift crypt, and they were almost erased by the tracks left by the dragged coffin.

There was only a single set of tracks.

It was then that they noticed the handles of the coffin were also smeared with the gray-green mold. It was if the Mold Man had somehow came out of the coffin and dragged it back to his original resting place.

But that was physically impossible. Wasn't it?

Nevertheless, a close look at the corpse and the fallen mold made everyone present shiver. They were the same material. Once again, the body was laid to rest in the mausoleum, and the funeral director brought in a Catholic clergyman to once again give Last Rites and a blessing on the tomb.

Mold Man stayed put this time.

After that, the maintenance crew always gave his crypt special attention. They always feared that one morning they would find it open again and see the evidence of Mold Man once again walking the earth.

When you work at a cemetery for any length of time and meet others who have lived the life of a gravedigger for years, you hear some strange and unexplained stories. You always hope that you are not the next one to come in the next morning with fear in your eyes as you tell the others, "You are not going to believe this but…"

SHE WATCHES FROM
THE GRAVE

Candice Buchanan

Far from its main entrance, where the gravel road winds near the back gate, stands Green Mount Cemetery's haunted mausoleum. It is not especially large, but it is stately, with a small porch supported by four pillars. Its heavy, gray stone is contrasted by a tempting patch of color within. To get a good look, a passerby must climb the stairs to the narrow porch and come nose-to-nose with the crypt's glass doors and peer between the metal bars. On each side are four drawers, occupied and identified accordingly. On the back wall, in vivid hues and artisan craftsmanship, an elderly woman stares back from a stained-glass window portrait. Her expression is stern, but it is her eyes that are haunting. As you study her, she studies you back. There is an eerie feeling of being watched. According to legend, her eyes actually move to follow visitors until they are safely out of range. Local lore explains that she holds this eternal vigil because her husband wronged her in life, and she is forever watching him in death. Other versions say that she guards her family from beyond the grave, with her eyes not only on anyone who approaches from the outside, but also on everyone entombed on the inside. Children who play hide-and-seek games in the cemetery see her both as protector, using the mausoleum as safe base, and as opponent, identifying her as the threat to either hide or run from.

Known most often simply as the "haunted mausoleum," the structure stands in section P, lots 49 and 50. The lots were purchased on July 18, 1924, by brothers Joseph T. and James J. Martin, whose initials preside over the crypt's entrance. The mausoleum was constructed in the same year and

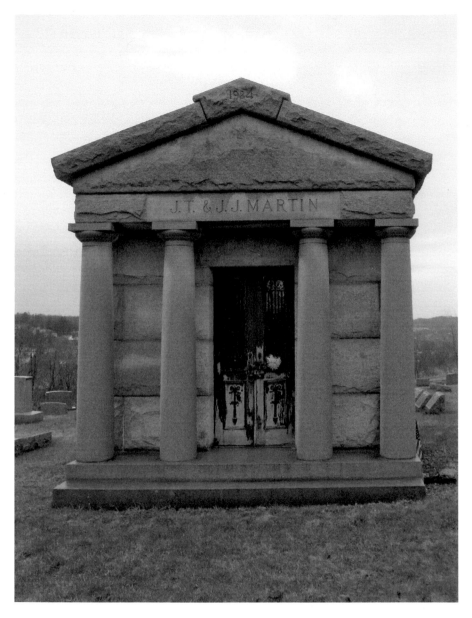

The Martin mausoleum in Green Mount Cemetery. *Courtesy of Candice Buchanan.*

marked with the date at the roof's peak. The first record in the lot book is for Maud Martin, daughter of Joseph. Her sudden death on July 12, 1924, was likely the event that prompted her father and uncle to purchase the property

and initiate construction. A crossed-out notation in the cemetery's interment book indicates that Maud may have been temporarily buried in section G until the mausoleum was completed.

Maud was not the only family member buried elsewhere until the tomb was ready. Disturbed graves and ghost stories go hand-in-hand, and digging up graves to remove and reinter relatives was familiar practice at Green Mount.

Upon its establishment by an Act of the General Assembly of the Commonwealth of Pennsylvania on April 15, 1853, Green Mount became the foremost burial ground for Waynesburg and the surrounding area in Greene County. Several nearby community and family cemeteries that had been in existence prior to its formation were eventually consolidated at Green Mount as their properties were reclaimed for modern development. In many cases, Waynesburg families preempted these mass relocations by buying lots into which they could remove ancestors from older cemeteries to Green Mount so that the past and present generations were buried together. Green Mount records note that between May 19 and 21, 1926, the Martin family removed the remains of four relatives from Fredericktown, Pennsylvania, to be entombed in the new mausoleum. One of those four was Martha (Moor) Martin (1819–1880), mother of Joseph and James.

Though no name is printed on her stained-glass window, there are notations at each bottom corner in a thin black script that is almost lost in the brightly colored design. Each has a date: "Born Oct. 21, 1819" and "Died Sept. 18, 1880." In a tribute to their mother, Joseph and James added these inscriptions to mark the timeline of Martha (Moor) Martin's life. Deceased long before the mausoleum was built, Martha did not select or order her own image to preside over the family; they chose it to remember her. Her prominent location is one of honor by her heirs, rather than sinister dominance over them. Martha's identity removes some of the chill from her intimidating presence, but as to the watched feeling—it merely names the watcher.

In addition to the Martin relatives who rest within the actual building, there are two buried in front of it. The pair of graves outside belong to Martha's grandson Edward Martin and his wife, Charity (Scott) Martin, who both lived from 1879 to 1967. Edward entered the military while a student at Waynesburg College and rose to the rank of general. Equally successful in politics, he served as governor of Pennsylvania (1943–47) and as a U.S. senator (1947–59). Though Edward and Charity are memorialized apart from the mausoleum that his father and uncle built, Edward's

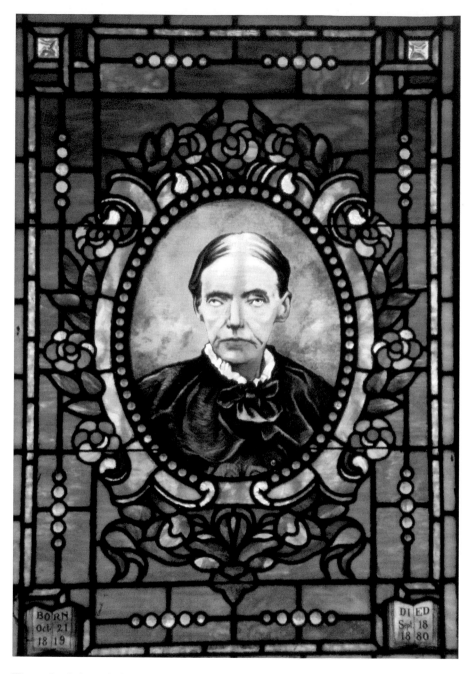

The stained-glass window depicting Martha Martin in the Martin mausoleum. Her eyes are said to follow visitors. *Courtesy of Candice Buchanan.*

Opposite: An original photograph of Martha Martin. *Courtesy of the Greene County Historical Society.*

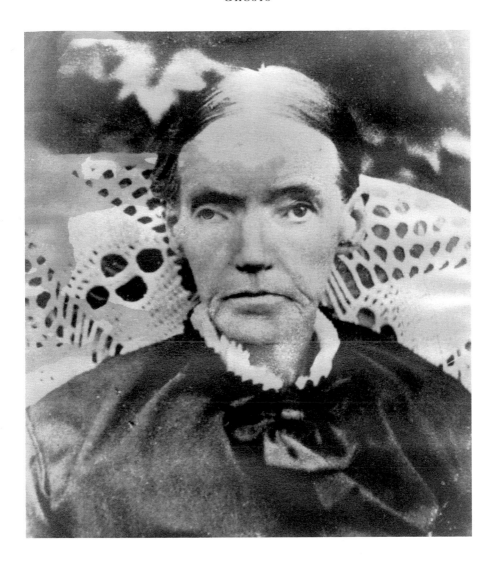

prestigious career contributed to the safekeeping of his family's history and the preservation of a rare record that helps to unlock the mausoleum's mystery. In the archives of the Greene County Historical Society, where a large Edward Martin Collection is housed, his grandmother's familiar gaze can be met once again, this time in an actual photograph. In the picture, Martha's eyes sit in exactly the same uneasy positions that they do in the crypt window. In life, Martha had a condition that actually caused her eye to wander. Preserved unedited by the artist, this eye condition recreated in stained glass lends itself to the illusion of watchfulness.

Her identity known, her place of honor recognized and her eyes understood, there remains one element of the ghost story that the archives cannot reconcile. The most popular telling of Martha's tale consistently claims some wrongdoing by her husband in life that causes her to be ever watching him in death. Martha's crypt identifies her as "Martha Moor, wife of John M. Martin," but there is no space labeled for John. Though Martha was one of four burials removed to Green Mount from Fredericktown in 1926, the accompanying three were her parents and her daughter; her husband is not listed.

When Martha died, John M. Martin (1823–1903) was fifty-seven years old. With a lot of life still ahead of him, he buried Martha with her parents in Fredericktown and then he started over. On February 1, 1881, four months after Martha's death, her widower was married to a woman twenty years younger than he, widow Isabelle (Barr) Montgomery (1843–1930), with whom he raised a second family.

The sons of John and Martha (Moor) Martin brought their mother to the mausoleum and put her picture in the window but left their father where he lay. John was not buried with either of his wives. He rests with his father and a son by his second marriage at Amity Cemetery in Washington County, Pennsylvania.

In the end, the one piece of Martha's mysterious stare that cannot be reasoned away is the possibility that she really is forever watching for her absent husband.

SOURCES

Amity Cemetery (Amwell Township, Washington County, Pennsylvania). Martin tombstones.

Biographical Directory of the United States Congress, 1774–Present. http://bioguide. congress.gov, 2014. Edward Martin biographical sketch.

Green Mount Cemetery (Waynesburg, Greene County, Pennsylvania). Interment books. Maintained by the Green Mount Cemetery Board, Waynesburg, Pennsylvania.

———. Lot books containing hand-drawn plats with corresponding burial lists. Maintained by the Green Mount Cemetery Board, Waynesburg, Pennsylvania.

———. Lot deed. Deed includes "Rules and Regulations" section under which item number IX defines the incorporation of the cemetery. Collection of the author, 2013.

————. Martin mausoleum and tombstones, section P, lots 49 and 50; personally read and photographed by Candice Buchanan, 2010.

Martin, Edward. *Always Be On Time: An Autobiography*. Harrisburg, PA: Telegraph Press, 1959.

Martin, Martha (Moor). Photograph, Edward Martin Collection, Greene County Historical Society (Waynesburg, Pennsylvania). Online image digitized by Greene Connections: Greene County, Pennsylvania.

Photo Archives Project. http://www.GreeneConnections.com (Item# GCHS-AN026-0128).

Smith, G. Wayne. *The Waynesburg Commons and Parks*. Waynesburg, PA: Cornerstone Genealogical Society, 2004.

Waynesburg College Alumni Office, comp. *Waynesburg College Alumni Directory 1966*. Waynesburg, PA: Sutton Printing Co., 1966.

Waynesburg (PA) Republican. Martin obituaries dated August 6, 1903; July 17, 1924; November 27, 1930.

SLAG PILE ANNIE

Thomas White

For well over a century, the economy of western Pennsylvania was dominated by the iron and steel industries. Though only a few mills remain today, the stark industrial leviathans drew thousands of workers and immigrants to the Greater Pittsburgh area, defining the region's life and culture. Like any other business or institution that impacts the lives of many people, the mills developed their own set of folklore and legends. Some of those legends were ghost stories.

Working in the steel mills was dangerous. Before better safety measures were implemented, thousands of workers would be killed or maimed on the job every year. Even after safety precautions improved, there were still numerous injuries and deaths. As one might expect, tales of ghosts and hauntings have been linked to those horrific accidents. One of the most popular of the steel mill "ghosts" is Slag Pile Annie. Several variations of her story have been told over the years, but the most common version was recorded by local folklorist and writer George Swetnam in the early 1960s.

In the early 1950s, a local college student who was attending the University of Pittsburgh got a summer job in the Jones and Laughlin Mill in Hazelwood. He was assigned to drive a buggy that pulled empty hopper cars through a tunnel that ran under the blast furnaces. After the furnaces were empty, the young man drove through and picked up the hot slag that had spilled during the steelmaking process. When he filled his hopper cars, he took the material to the slag dump.

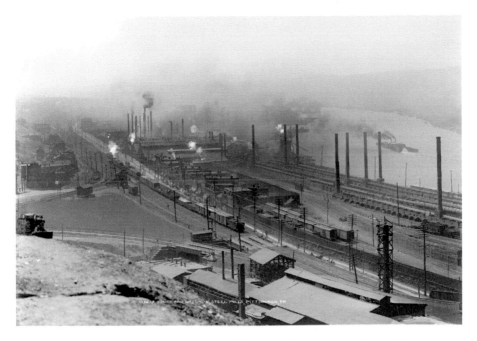

One of the Jones and Laughlin steelworks in Pittsburgh. *Courtesy of the Library of Congress.*

One day, while making his run through the poorly lit tunnel, the young man spotted a woman who was wearing work clothes and a red bandanna in her hair. She was in her late forties or early fifties. He pulled his buggy up beside her and warned her that she could get killed in the tunnel if she was there at the wrong time. The woman looked directly at him with an unnerving stare and said, "I can't get killed, I'm already dead." The young man was not sure what to do, so he continued his run. When he finished, he approached the foreman and told him about the woman. After the young man described her, the foreman told him that he had met Slag Pile Annie.

Annie had started working in the mill during the Second World War. Many women had filled the mill jobs that were left vacant when the men went off to fight. When the war ended, she continued at her job, which happened to be driving the buggy and collecting slag. About five years before the young man came to the mill, Annie was killed in an accident. Details of the incident are vague, but somehow Annie was burned by the hot slag. In the years after the accident, Annie's ghost was often reported in the tunnel where she met her demise.

The story of Slag Pile Annie, whether true or not, served other purposes in its retelling. Such stories were a warning and reminder of the constant dangers of the mills, even for those who performed rather mundane jobs. Slag Pile Annie's story also carried part of the mill's history. It was a memory, or commemoration of sorts, of the important role that women had played in industry during the war and the sacrifices that they made in the process. Some even sacrificed their lives supporting the war effort.

SOURCES

Swetnam, George. *Devils, Ghosts and Witches: The Occult Folklore of the Upper Ohio Valley*. Greensburg, PA: McDonald/Sward Publishing, 1988.

Trapani, Beth E. *Ghost Stories of Pittsburgh and Allegheny County*. Reading, PA: Exeter House Books, 1994.

MARY BLACK'S GRAVE: THE ANATOMY OF A LEGEND TRIP

Gerard O'Neil

Legends and folktales can serve as societal mechanisms for maintaining community identity, keeping people "in line" and helping to delineate boundaries. Folklorist Bill Ellis has provided an excellent illustration of this phenomenon. In his book *Aliens, Ghosts and Cults: Legends We Live*, camp counselor Bill Henry tells a scary story about a psycho killer titled "Ralph and Rudy," with the intent of ensuring that the children remain in their tents at night. In interviews with Lawrence County residents, the legend of the alleged witch Mary Black is found to serve similar societal purposes, both within western Pennsylvania families and for Lawrence County youth who set forth on nocturnal visits to her grave. This analysis of a local storytelling process examines themes or functions including boundaries, rites of passage, legend tripping, community memory, marginalization and ambiguity.

One thing about the legend of Mary Black is unambiguous: she was a real person buried in the Tindall Family Cemetery in Shenango Township. Before examining the legend in depth, a short explanation of the historical Mary Black is in order. Mary Johnson was born in Ireland in 1801, married Andrew Black around 1831 and immigrated to America shortly after. She died in 1888, having outlived Andrew by twenty-seven years. They were both buried in a private cemetery located on the Tindall homestead in the extreme southwestern corner of Shenango Township. Descendants of Mary Black continue to maintain that she was not a witch and was not known by any other name, nor was she reputed to be a witch during her lifetime.

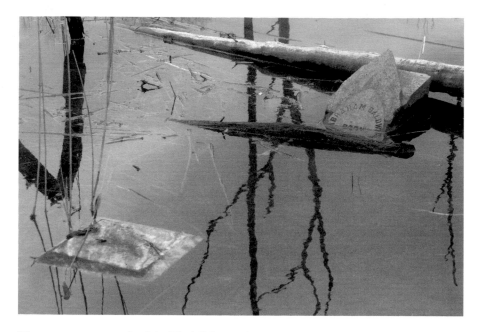

Water now covers much of the Tindall Cemetery, including the Baldwin family stone and its base. *Courtesy of Jeff Bales at Lawrence County Memoirs.*

So how is it that she is now said to have been a witch, when there is no evidence suggesting that she was accused of witchcraft during her lifetime? Here we must introduce another curious character: Harry Stein (1903–1980), better known as "Harry the Hermit." Lawrence County residents commonly credit the idea that Mary Black was a witch due to his legendary storytelling. However, Stein's *Memoirs of a Backcountry School,* a rambling Faulkner-esque manuscript owned by the New Castle Library, only confuses the legend. The manuscript mentions (the apparently fictitious) Lisa Sturner, a fearsome witch who owned a mysterious Oriental cat the size of a small bear. It is possible that Harry and/or his audiences conflated the names or that he deliberately avoided using the name Mary Black in writing because she had living relatives.

Collecting legends is a messy process. While tales surrounding Mary Black's grave remain popular in western Pennsylvania, the legend is now less of a story and more of a summary or passing reference to a person who may or may not have been a witch. A capsule version of the Mary Black legend goes like this: if you go to her grave at midnight and say her name three times, something unfortunate will befall you. Cold hands may reach

out of the ground, grab you in the dark or push you so that you fall down in the mud. Mary Black's gravestone is reported to have special powers; if you try to steal it from the cemetery, it will get heavier and heavier until finally you must set it down—but the stone will return to its proper place by itself. Saying Mary Black's name three times at her grave site may cause her spirit to afflict your animals, make you sick or lead to general misfortune. The traditional notion of witches injuring animals may seem trivial when repeated in current narratives, but for struggling rural agriculturalists, sick livestock was a persistent threat to their livelihood. Nowadays, the ghost of Mary Black also has a penchant for afflicting cars, as most Lawrence County residents do not own livestock.

Part of the problem with "collecting the story" is that an interview is not the same as a typical storytelling setting, where participants can contribute to the story, add details, comment on the narrative and manifest the tensions between skepticism and suspension of disbelief. A transcript is not the story as told by individuals in diverse social settings. Folklorists speak of legend ecologies, and the story of Mary Black, as told by one informant, clearly exists in two different ecologies. The story functions as a warning to young children; later in life, adolescents challenge or test this established authority, and Mary Black is the outcast and scourge of authority in both legend ecologies.

There is a crucial problem inherent in attempts at locating belief legends in their natural habitat. Members of a culture frequently make oblique references to information that all members are presumed to know, and the belief system is never presented explicitly in its entire scope for the benefit of an outsider. Folklorist Linda Dégh has stated rather adamantly, "Direct questioning of chosen individuals to solicit legends leads nowhere." Legends are embedded in the discourse of a specific community, and outsiders are inevitably identified by their lack of mastery of that discourse. However, interviews enable some reconstruction of the two salient legend ecologies in a clearly defined recent time frame: the 1990s. The recollections of one Lawrence County resident, referred to as "John" in this analysis, are particularly helpful in examining both legend ecologies.

The theme of boundaries can be used to connect or examine all of the other themes. Therefore, the idea of the liminal is best examined first. Anthropologists have long noted that boundaries must be defined and approached with care because dangerous power is present or invoked where boundaries are crossed. Delineation of boundaries is a readily apparent theme in John's account. As an eight- or nine-year old, John first heard of Mary Black from his great-grandmother when he misbehaved and was told

that if he kept acting up, the ghost of Mary Black would haunt him. This misbehavior included crossing literal physical boundaries as well as societal limits. John tells us, "My grandmother had a large set of property [about a mile away from the Tindall Cemetery] and if I were to be getting into something that I shouldn't be getting into [he would be threatened with Mary Black's ghost]. I was not allowed in the basement. I was not allowed upstairs." Clearly resembling Bill Henry's behavior modification philosophy concerning campers, John's interpretation of these events twenty years later was explicit:

> *After hearing the story initially, it kind of provided me with this creeped-out sense of that area, and I guess it kind of made me more aware of the direction that my grandparents were trying to guide me in when they told me, tried to correct my behavior about something…children, I think, when they're told a scary story, it's kind of engraved in their memory. If I'm getting out of line, my grandmother would say something about having Mary Black's ghost come after you. So, in that sense the idea of that possibly happening kind of instilled this fear in me.*

One reading of this belief legend scenario would be that crossing certain lines will make the instigator socially unacceptable, like the witch Mary Black. The implied threat is "You will become like Mary Black—[an] outcast—if you don't behave!" To a child, the warning "A witch will get you!" was both memorable and transferable to numerous transgressions, hence the utility of framing behavioral corrections in this manner. Mary Black's legendary occult powers represent society's powers to ostracize and marginalize in a form accessible to children. John stresses the emotional state, or affect, that follows from hearing the legend and its associated threat. In adolescence (which is itself a liminal region), increased freedom and mobility enable individuals and groups to deliberately set out to prove boundaries; the legend ecology, and affect, is transformed.

For adolescents, experiencing the legend of Mary Black moves beyond the verbal to include visiting her grave at night, and all members of John's family, including his mother and older brother, have done so. This process of including the listener and storyteller in the legend itself by interacting with the legend is termed "ostension," which means "showing." The act of showing the legend site to others is referred to as a "legend-trip." The important concept is that the legend trip is more than a telling of the story; it is an act that places the listeners *in* the story. According to Elizabeth Bird,

The Aiken family stone is one of the few not underwater. *Courtesy of Jeff Bales at Lawrence County Memoirs.*

"During the legend trip, within a frame of playful fear, young people are able to explore and confront some of the concerns that face them in 'real' life, through the potent interaction of texts, environment, and action. The legend texts have little power on their own."

Without a dramatic setting, the legend lacks affect. A typical legend trip destination is usually isolated, but not too inaccessible, and many trips specifically incorporate automobiles into the ostension itself. In the instance of Mary Black, it would be difficult to reach her grave without a car, but some hiking is still required. The adolescent legend trip is a dare as much as a warning, but a fairly safe boundary or limit is tested in both the physical and societal senses—driving fifty miles per hour over the speed limit would be both socially unacceptable and truly physically dangerous, while thrashing through dark and unfamiliar woodlands in search of a solitary grave poses a modicum of risk. Most participants interviewed about local legends were willing to trespass but drew a line at breaking and entering. Over the years, Mary Black's grave and the nearby Tindall graves have been heavily vandalized. While regrettable, this destructive activity is frequently an integral part of the legend trip; Bill Ellis informs us, "To say that desecrating

Vandals dug up a grave by the Aiken family stone. *Courtesy of Jeff Bales at Lawrence County Memoirs.*

a witch's tombstone fulfills the terms of an initiation evades the real issue: Why should the ritual require vandalism? The answer seems to be that the legend-trip is more than an initiation into the supernatural; it functions in the same way as other adolescent automobile activities—that is, as a 'ritual of rebellion.'"

For many adolescents, property destruction at a safely remote location is a readily crossable boundary, particularly when under the influence of drugs or alcohol (yet another boundary tested in the process). With freedom comes an exploration of ethical boundaries. Elizabeth Bird expands on Ellis's idea of a ritual of rebellion: "The trip is one of the few events that belong to adolescents, without adult supervision and even awareness. During the trip they explore the rules of the fast-approaching, real, adult world through the rules of their game, a game of which adults may be but dimly aware. The experience is an act of resistance to adult roles; the young people in effect write the script for the play."

And yet, the plays adolescents write are inexorably rites of passage, and challenging or testing the Mary Black legend fits this pattern. In anthropology, a rite of passage is usually defined as a ritualized death experience followed by

a symbolic rebirth, which can include tests of bravado for male participants. While it might be a stretch to call walking back to your car a rebirth, it is a return to civilization, a retreat from a liminal zone. The death experience is relatively safe, and adolescents can reasonably expect they will survive the ostensive ordeal. This particular legend contains elements of confronting and acknowledging mortality to move beyond child-like conceptions of death, while leaving many unanswered questions about death.

Ambiguity has played a key role in the story for high school students, because many people questioned whether there even was a grave. Folklorists have determined that ambiguity does not lessen ostensive drama; instead, tension is increased by the lack of resolution, and subsequent discussion and interpretation form an essential part of the legend trip process. In John's account of his mother's trip to the site, he says:

> *Well, they went out there and it—and honestly I think the effect it had on them was just kind of—it scared them, because there are different stories about it. Some people say there isn't a tombstone out there, some people say there are, and then, actually finding a tombstone out there kind of gives a certain validity to the stories that you're told, as a kid. So, if anything I think it just kind of scares people.*

The word "validity" occurs several times in the interview as John returned to the importance of showing others that at least part of the legend is true. However, in this interview it is never made very clear what, exactly, Mary Black will do, nor is a prescribed ritual given for invoking her; there may be an assumption that the listener understands oblique references because he or she already "knows" these things. Some questions emerge about the purpose, interpretation and emotional affect of this teenage ostensive drama: Does this ostensive act mock death or acknowledge its finality? Is Mary Black to be mocked, feared or pitied? Even the effect of her ghost on automobiles is ambiguous. You could get a flat tire when visiting Mary Black's grave, but there is a rational explanation available: the road once served as an illegal dump site, and puncturing a tire on debris was a very real possibility.

A solitary grave at a swamp's edge in a remote illegal dumping ground indicates a theme of marginalization. Presumably, Mary Black is marginalized in death as she was in life. And yet, there is an indication of cultural ambiguities in attitudes toward marginalization, which are explicitly examined, although by no means resolved. According to John:

The reason why they buried her—why I was told that she was buried out there—was because of her being a witch, quote/unquote, that they kept her body away from the other cemeteries around the area, because of her witch practices and things like that, what she did while she was alive, and the things that that entails…it's rumored that she was involved in various black magic acts, and back in the 1800s there were, I guess you could say, very negative mainstream views about that, which is what led to her persecution as being a witch.

Later, when examining why people might refuse to believe there is an actual grave in the woods, John tells us:

I guess to downplay the story and kind of make it seem like it's not—maybe it's just like some sort of urban legend or suburban legend in this case. I mean, maybe people don't believe in how people were treated back then if they had certain kinds of beliefs. Maybe people don't want to admit that there was somebody from that area that was practicing witchcraft, because of religious convictions or something like that…maybe some people would just try to deny it for the sake of it being a negative image of the area that it takes place in, or that it's found in, I should say.

These responses illustrate how all legends are "contemporary"—that is, they reflect the belief system of the teller's culture. In this instance, the belief system is not homogenous, and the unresolved conflicts sustain the psychological resonance of a contemporary legend. Interpretation is ambiguous, as are the legend and the legend–trip experiences themselves.

Conflicting elements of community memory are found in the story as well. Early settlers lived a lifestyle inconceivable to adolescents today, yet the near-emptiness of the Turkey Hill area serves as a vivid reminder of the region's rural past and belies the fact that a limestone mining operation is slowly encroaching on the site. A neighboring hill has been heavily quarried, and three-hundred-foot slag heaps loom over the cemetery on either side.

The Tindall family, while duly noted online as community founders, is not even mentioned in many versions of the Mary Black legend; her tombstone is said to be by itself. However, the Tindalls were buried not far away, and consequently, their family cemetery has suffered considerable vandalism as well. In an era where "slash-and-burn development" replaces farms and factories with developments like "Trotting Acres" and "Allegheny Mills," the legend of Mary Black serves as a faint reminder of rural life before the

After attempted thefts, Mary Black's gravestone is now preserved by the Lawrence County Historical Society. *Courtesy of Michael Hassett.*

onslaught of the forces of homogenization and corporate commemoration. When directly asked why he returned to the grave site in the daytime so that he would not get lost showing the site in the dark, John's reply reiterated his idea of validity, concluding, "Just to be able to say 'Hey, this part of it is true.' You, know, to let the story live on a little bit, I guess." Despite the overwhelming power of mass media, the transmission process remains active in an oral form.

Ironically, the retelling of local lore is part of a process of resistance to homogenization of the American landscape, culture and media, which is subsequently embedded in, and intertwined with, processes that enforce homogenization. In particular, the dissemination of a story that asserts local distinctions through mass media such as books, television and the Internet can serve to homogenize that same story and perhaps to alter its societal functions.

Bill Ellis has examined the role of memes, replicating virus-like thoughts analogous to genes, in the legend transmission process and emphasized that legends can readily serve to defend local identity. Ellis also presented a converse identified by Linda Dégh: cultures create anti-legends that attempt to attack and destroy a legend. These conflicts are apparent in the ambiguities that surround the legend of Mary Black. The Internet has introduced another problem: it is an ideal vector for mimetic dissemination that is often mere "cut and paste" transmission; closer scrutiny of the Mary Black legend online undoes the apparent variety of sources.

A final irony is that a community memory legend has actually served to obliterate part of the memory. The grave marker is no longer at its original site but is stored at the Lawrence County Historical Society for safekeeping. The impact of the ostensive process may be lessened as a consequence of the reduced ambiguity surrounding her grave, and adolescent exploration of boundaries in Lawrence County may not be the same.

SOURCES

Bird, Elizabeth. "Playing with Fear: Interpreting the Adolescent Legend Trip." *Western Folklore* 53, no. 3 (July 1994).

Dégh, Linda. "What Is a Belief Legend?" *Folklore* 107, no. $^{1}/_{2}$ (December 1996).

Ellis, Bill. *Aliens, Ghosts, and Cults: Legends We Live.* Jackson: University Press of Mississippi, 2001.

Hopkins, G.M. *Atlas of the County of Lawrence and the State of Pennsylvania.* Philadelphia: G.M. Hopkins & Co., 1872.

Litowitz, Pat. "Lawrence County Historical Society Director Separates Fact from Fiction on a Few of County's Famous Myths and Mysteries." *New Castle News*, October 28, 2007.

Presnar, Robert. "The Legend of Mary Black." *New Castle News Online*, October 25, 2011. http://www.ncnewsmedia.com/archive/2011/Halloween_11/STORIES/SPOOKY/index.htm.

Tucker, Elizabeth. "Ghosts in Mirrors: Reflections of the Self." *Journal of American Folklore* 118, no. 486 (Spring 2005).

THE HISTORIC AND HAUNTED DRAVO CEMETERY

Stephen Bosnyak

For quite some time, the possibility of an encounter with the supernatural has been luring paranormal investigators to a remote corner of Allegheny County. The location is appealing because it is what many would consider to be the perfect backdrop for a ghost story. That location is the Historic Dravo Cemetery in Elizabeth Township.

Established along what is now the Great Allegheny Passage, the two-hundred-year-old cemetery has recently become a popular destination for history buffs and outdoor enthusiasts as well. For some, it is a window to the past. To others, it's merely a pleasant spot to rest before continuing on the recreational trail. Ironically, this particular area has always been a sort of gathering place for the community.

In the late 1700s, a European immigrant by the name of Nathan Newlon made a new life farming the land just west of the Youghiogheny River. As his farm and family flourished, Newlon was able to purchase additional property for crops and livestock. One of the parcels that he acquired was a grassy knoll that stretched from the riverbank to a small wooded gully. Like early settlers often did, the young man converted part of the property into a cemetery for the departed members of his family. Eventually, the peaceful slope overlooking the river would also become the final resting place for Newlon after his passing in 1820.

Around the same time, the extraction of Pennsylvania's natural resources triggered a number of employment opportunities across the region. With that came a dramatic increase to the population. Small mining villages

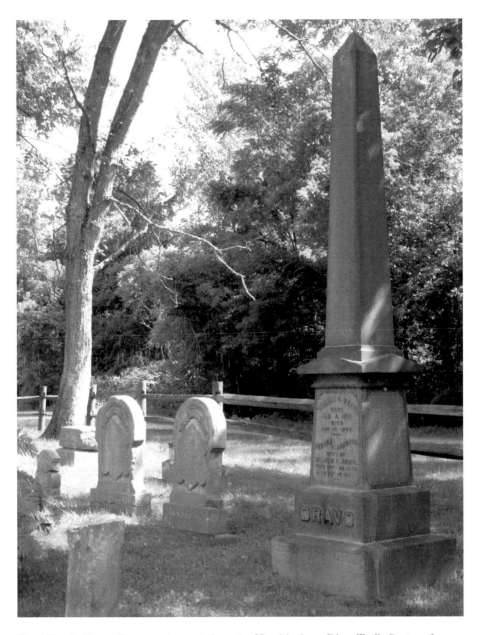

The Historic Dravo Cemetery, located along the Youghiogheny River Trail. *Courtesy of Stephen Bosnyak.*

were appearing all throughout the Youghiogheny River Valley. Most of these budding communities consisted of only four or five houses and were usually named after the first family to establish a residence there. The village closest to the Newlon's cemetery sat along a single-lane road that had been cut into the rugged hillside. Those living in the vicinity referred to the tiny hamlet as Stringtown because its houses appeared to be "strung together" in a straight line.

To help accommodate the growing population, certain improvements were made around the community. One of the most noticeable changes occurred after the Reverend William Dravo saw that the local Methodist congregation had outgrown the walls of the church he presided over. Because he was a dear friend of the Newlons, Dravo asked the family to grant him permission to build a new church on the property adjoining the cemetery. The Newlon family agreed to the reverend's request without hesitation.

By the summer of 1824, construction was well underway on a new Methodist church. Once the ground in front of the cemetery was leveled, the foundation stones for the building were set in place. Next, the wooden framework for the two-story structure was erected on the site. Upon its completion, the new church was said to be large enough to accommodate nearly two hundred parishioners.

Over the next four decades, the Dravo Methodist Church continuously served the mining and farming communities on both sides of the Youghiogheny. During this time, new faces were always appearing in the crowd that gathered for the weekly sermon.

Then progress came knocking at the door of the peaceful countryside. In 1875, the Pittsburgh and Lake Erie Railroad Company began clearing timber for the development of a new rail line in western Pennsylvania. This particular branch was set to stretch from Pittsburgh to Connellsville, with most of its rails following the winding path of the Youghiogheny River. During the early days of construction, members of the Dravo Methodist Church expressed their concerns with having the railroad tracks so close to their church. Many believed that the noise from passing trains would become a major disruption to the sermons. When the tracks finally went into service in 1882, the sounds of the railroad did become somewhat of an annoyance to parishioners. With time though, the congregation of the church became accustomed to the sporadic rail traffic.

According to historical records, the unimaginable happened just before the turn of the century. Arriving for Sunday service, members of the congregation were stunned to find the smoldering remains of what had once

been their beloved church. Friends and neighbors immediately began to question the circumstances behind the devastating fire. All others could do was weep. Despite their dismay, all of those present were thankful to learn that no one was inside the church at the time of its destruction.

In the weeks that followed the tragedy, the facts surrounding the blaze were still unclear. Regardless, the congregation made good on their vow to rebuild. The brand-new house of prayer eventually appeared above the foundation of the previous church. In no time at all, church services resumed along the peaceful riverbank.

Much to the shock of its older members, the congregation found themselves facing the exact same devastation again in 1924. Just as it had happened nearly a quarter century before, another fire roared through the church and burned it to the ground. Once the terrible news spread throughout the valley, some residents refused to believe it. Instead, they rushed to the churchyard to see the truth for themselves. What they found was another gathering of people around the charred ruins. Only this time, there was suspicion of arson.

Eventually, local authorities determined that the fire had been ignited by sparks flying out from underneath passing freight trains. Suddenly, all of the unanswered questions pertaining to the first church fire were no longer a concern. However, some residents did wonder why a connection between the original fire and the railroad hadn't been made sooner. Safety and financial concerns would eventually bring church leaders to the difficult decision of not rebuilding the church next to the railroad tracks. Those who regularly attended services at the Dravo Methodist Church were then directed to the other Methodist churches in the area.

With the silhouette of the Dravo Methodist Church missing from the river's edge, superstitious residents were soon regarding it as an omen. Oddly enough, it very well could have been. Within a few years, the mining companies that once thrived in the Youghiogheny River valley were beginning to shut down operations. Disappointed employees were now forced to find work elsewhere. Because of this, entire mining villages suddenly became vacant. In time, even the mighty P&LE railroad company would allow its rails to rust away when it abandoned its Youghiogheny Branch.

Almost fifty years would pass before the Dravo Cemetery and the ghost towns along the Youghiogheny returned to the public eye. According to local lore, the woods surrounding the old cemetery became the setting for a tale that some called too ridiculous to be true. As the story goes, a college fraternity from the Pittsburgh area held an initiation for potential members

near the cemetery during the 1970s. Supposedly, the active members of the charter used flashlights to lead four freshmen through the darkness to a predetermined location by the P&LE railroad tracks. Once there, all four pledges were provided with shovels and instructed to dig their own shallow graves. When the task was completed, each candidate was handed a cardboard tube from an empty paper towel roll. Next, the young men were ordered to "die" for the college brotherhood. Without objection, each pledge found his place in an open grave. After making sure that the cardboard "breathing" tubes were in place, those left standing proceeded to bury the pledges beneath a thin layer of cold damp soil.

After completing the first part of the ritual, the senior members of the fraternity made their way across the railroad tracks to the cemetery. With a few large tombstones serving as seats, the young men began to pass around a bottle of alcohol. Once thirty minutes had passed, the brotherhood noisily returned to the woods to "resurrect" the pledges as new members. According to those familiar with the story, that was when the problems started. Presumably, the alcohol made it extremely difficult to relocate the buried pledges. It was said that the senior members spent the rest of the night searching for the cardboard tubes protruding out of the loose dirt.

Since there were never any police reports filed, most people tend to agree that the four college students eventually made it out of their shallow graves. The manner of how it happened is questionable, though. Of course, there are those storytellers who still like to imply that the pledges were never found.

It wasn't long before there was something new for the community to talk about. In 1986, the Elizabeth Township Historical Society made an announcement that it had acquired the Dravo Cemetery from the Methodist Conference of Pittsburgh. Through fundraising and volunteer donations, the nonprofit organization was able to begin work on restoring the neglected cemetery. In the process, members of the historical society made some very interesting discoveries. Their research indicated that the Dravo Cemetery was the final resting place for over seven hundred citizens of the Youghiogheny River Valley. Of that total number, though, only eighty-one of the burial plots in the cemetery had identifying markers.

Another surprise came with the discovery of headstones that belonged to nine veterans of the Civil War and one veteran of the War of 1812. Of course, both members and volunteers agreed that the most solemn find at the cemetery was the number of markers that belonged to young children. This provided the local historians with evidence of early childhood illnesses in the western Pennsylvania area.

Dravo Cemetery may be the resting place of almost seven hundred people, though only eighty-one plots have markers. *Courtesy of Stephen Bosnyak.*

While the Elizabeth Township Historical Society continued its work at the cemetery, other nonprofit organizations from the area were taking an interest in another project close by. In the mid-1990s, a joint effort was underway to connect the city of Pittsburgh to the nation's capital through abandoned railroad lines. This project was called the Great Allegheny Passage and C&O Towpath. Locally, a 43-mile section of the 335-mile recreational trail was known as the Youghiogheny River Trail.

By the new millennium, the development of the Youghiogheny River Trail corridor of the Great Allegheny Passage was moving forward. The steel rails of the former P&LE railroad line had long since been removed, and a smooth bed of crushed limestone had taken their place. Trailhead parking lots, along with signage and benches, were appearing in the towns of Boston, Sutersville and West Newton.

With community interest in the new trail on the rise, the Elizabeth Township Historical Society seized the opportunity to generate additional funding for the preservation of the cemetery. It soon became evident that

the volunteer activity in and around the cemetery was sparking the interest of those who were now making use of the recreational trail. Due to the large number of individuals stopping at the cemetery for a closer look, a pavilion with picnic tables was constructed on the site of the former Methodist church. Additional park benches and a rustic split-rail fence were also installed on the property. The final act of restoration came when a bronze plaque commemorating the history of the Dravo Methodist Church and Cemetery was added to the entrance. For many, the unveiling of the monument gave the cemetery the historical status it deserved in the community.

Just a few steps away in the meadow bordering the cemetery, another project was taking shape. An organization known as the Regional Trail Corporation was developing an area to be designated as a primitive campground. With plenty of shade trees and convenient access to the riverbank, the location seemed ideal for providing visitors with a place to unwind after a day on the trail. The discovery of a well, thought to belong to the Newlon family, quickly became an asset to the campsite once the test results deemed the water safe for consumption. Not long after that, other amenities such as a bicycle rack, public restrooms, benches and fire rings became welcome additions to the site.

Curiosity about the cemetery really peaked when a local newspaper featured an article about it in 2001. Suddenly, people from all over the Pittsburgh area were now making the trek to the historic site. Unknowingly, a few of those visitors would return with more than just memories of a relaxing day on the trail.

Some of the very first stories of strange sightings in the cemetery actually came from those passing by on the Youghiogheny River Trail. Rumors began to spread about apparitions standing among the tombstones. Most of these accounts usually occurred whenever trail users would glance into the graveyard. With a lengthy second glance, the shadowy figures that were thought to be there had disappeared from view.

Stranger yet are the tales of sudden and abrupt wind gusts that surprise trail users on relatively calm summer evenings. Those who have experienced this phenomenon first-hand often mentioned hearing the "chugging" sound of the steam locomotive just before being hit by a blast of bitter cold air. Most peculiar, though, was how the majority of individuals reporting these incidents had no prior knowledge to the tale. In fact, it was only after they shared the details of their encounter that they learned of what some call the "phantom train." As stories of the unseen train continued to spread, trail users were now speculating about a train derailment near the Dravo

Cemetery. Local historians, on the other hand, were quick to point out that no such accident was ever documented on that particular section of the P&LE railroad line.

For the most part, the strange happenings along the recreational trail have been harmless. It is actually the ones coming from within the cemetery that are thought to offer the most frightening interactions with the unknown. While on a weekend excursion along the Youghiogheny River Trail, a local Boy Scout troop was making use of the new campground outside of the town of Buena Vista. As the night grew dark, the Scouts gathered around the warm glow of a campfire and proceeded to share spine-chilling tales. It wasn't long before the conversation prompted a few of the Scouts to ask for permission to go and look for ghosts in the neighboring cemetery. Feeling that it was safe for them to do so, the three chaperones allowed the Scouts to go unsupervised. It was a decision that some parents would later complain about.

As it was told, there were plenty of giggles coming from the cemetery that night. The narrow beams from multiple flashlights scanned over the tombstones and cast shadows on those exploring the grounds. Soon all interest in finding ghosts turned into a friendly game of tag.

From the campsite, the scoutmaster could hear the sound of distant laughter over the crackling fire. Through the trees, he could track the Scouts' movement by watching the small circles of battery-powered light. Just as he was about to call the boys back over to the camp, the unexpected happened.

Without warning, a blood-curdling howl pierced the night. Suddenly, screams of terror echoed in the river valley. The adults in the group immediately dropped what they were doing and raced up the hill to the cemetery. Before they could reach the top of the knoll, the darkened outlines of children running came into view. The boys who were so eager to explore the cemetery were now out of breath and trembling in fear. Some of the boys were even crying. At that point, one of the teary-eyed Boy Scouts started to carry on about a vicious dog.

When he determined that no one was physically hurt, the scoutmaster asked one of chaperons to take the Scouts back to the camp while he and the other chaperone investigated the cemetery. Armed with flashlights and pocketknives, the two men searched the quiet graveyard thoroughly. Once they were satisfied that whatever had scared the boys was gone, the chaperones returned to the camp.

It was well after midnight before the Boy Scouts had finally calmed down. For a time, the scoutmaster had even contemplated packing up the tents

There are many that believe the cemetery is haunted by a ghostly two-headed dog, a phantom train and other spirits. *Courtesy of Stephen Bosnyak.*

and moving the troop out of the area. After the boys were asleep, the adults continued to whisper about the story that the boys had told them earlier. The three men were still having difficulty believing in the "glowing two-headed dog" that supposedly lunged out at the boys from behind a headstone. If it hadn't been for the unearthly howl that was heard before the Scouts panicked, those individuals watching over the group might have brushed off the entire incident as a hoax. For the rest of the night though, the scoutmaster kept a watchful eye on the cemetery.

In the years following the Boy Scout troop's encounter with the unknown, the story of the spectral two-headed dog continued to stimulate the imagination. The popularity of this legend has also brought a number of paranormal researchers to the cemetery in search of the ghostly animal. Some have theorized that the canine apparition is simply protecting his deceased master's grave and only becomes aggressive whenever someone gets too close. Others seem to think that a headstone with a dog etched on it indicates that the animal is actually buried in the cemetery.

Although the spectral dog has rarely been seen, its presence in the cemetery is made known from time to time. To date, there have been numerous trail users who have reported hearing "lonely howls" coming from somewhere among the tombstones. On occasion, some visitors to the campground have been brave enough to enter the cemetery and investigate the disturbance. So far, the results have been inconclusive.

Since its completion in 2013, the Great Allegheny Passage continues to attract visitors from near and far. Although the recreational trail appeals mostly to those seeking healthier lifestyles and leisurely activities, it has also opened the door for the exploration of lesser-known regional history. Because of this, the stories of the Historic Dravo Cemetery will always have a life…or would that be an "afterlife"?

THE LADY IN WHITE IN PENNSYLVANIA LORE

Rachael Gerstein

Why do people believe in ghosts or entertain the notion of their existence? Even many skeptics, who claim to completely reject the existence of ghosts, often still harbor a sliver of doubt. This is because ghosts carry many meanings. On one level, they provide people with proof that there is something beyond death. Ghosts are the evidence of man's immortality. On another level, ghosts can be manifestations of cultural ideas and forgotten historical events. Some ghost stories are archetypes, told over and over again in different locations around the world. One of these well-known types of ghost is referred to as the "White Lady" or "Lady in White." These White Ladies have been reported in areas of Germany, Ireland, Wales, Scotland and Britain over the centuries. Of course, the archetype of the Lady in White also made its way across the ocean and into the Commonwealth of Pennsylvania.

Traditionally, the White Lady has been linked to scenes of tragedy, most often the untimely death of a young woman. The Lady in White is sometimes said to appear because of the loss of her husband or lover, who might also have met a tragic demise (usually at the same time as the White Lady). Her apparition, obviously clad in white, is unable to rest because of her sudden, usually violent end. In European legends, the White Lady frequently guards or watches over some kind of treasure as well. This element has generally failed to transfer to America. Versions of the White

Lady in Europe are also frequently portrayed as being more aggressive than they are in America.

In Pennsylvania, two of the most popular White Lady legends are actually linked together. The stories of the White Lady of Wopsononock Mountain (frequently called Wopsy Mountain) and the White Lady of Buckhorn Mountain seem to have originated from the same source in the Altoona area. The mountains, which are next to each other, share very similar stories of the Lady in White. The legend of the spectral White Lady of Wopsy Mountain seems to be older and probably represents the original story. Over the years, many variations of the legend have been retold, mixing folklore with personal encounters. One of the most common, and possibly earliest, versions dates from the late 1800s and involves a couple who were involved in a deadly accident on a narrow mountain road. There are versions that claim the couple was eloping and was even being chased by the bride's angry father. The couple's horse and carriage lost control and wrecked going around the dangerous bend known as the Devil's Elbow. This very treacherous curve on the mountain has caused a great number of accidents over the years. The fate of the passengers depends on which version of the story that you hear.

Most often it is said that all onboard the carriage were killed. Some accounts claimed that the woman survived, only to discover that her husband had been decapitated. Of course, his head was never found. In the years since, numerous witnesses claimed to have seen the apparition of the distraught woman in a long white dress wandering near the bend, looking for something. She has been described by some witnesses as holding a lantern or candle. It is commonly believed that she is searching for her husband (or maybe his head), perhaps not realizing that she, too, was dead. The specter walks in the direction of Buckhorn Mountain, always disappearing near the Devil's Elbow.

The dangerous roads on neighboring Buckhorn Mountain are home to a very similar story set in a more recent time period. A young couple in a car, who are said to have been eloping, plunged off a dangerous bend in the road and perished. The road is often identified as Skyline Drive, but other roads have been suggested as well. The young man's body was found, but the young woman's was not. Since then, her ghost wanders the road in her white wedding dress, unable to pass on to the other side. Given the geographic proximity of the two mountains, and the similarity in the structure and content of the ghost stories, it is likely they were originally one legend that split into two.

The White Lady has also been reported at the Wopsy Lookout, known locally as a lover's leap. Over the years, several distraught young people have taken their own lives at that location. These tragic occurrences have inspired their own versions of the Lady in White legend. Though they vary in specific details, all involve a young woman whose life ends tragically in suicide and whose pale apparition now wanders the nearby roads.

Over the decades, some people have offered rides to the strange woman on the side of the road. Several years ago, a technician, who had just finished work, was heading down the mountain. He came to an immediate stop when he saw a beautiful woman dressed in white. She gladly accepted the ride that he offered and got into the back seat of his vehicle. The lady did not utter a word but kept a friendly smile on her face the entire time. The man could not see her reflection in the mirror, yet when he turned around, she was sure enough still sitting there smiling. Just as they approached the Devil's Elbow, the man turned around and realized she was gone. Numerous people have testified to this same sort of occurrence over the years, saying that the lady was quiet, smiled pleasantly and was extremely beautiful. Of course, this part of the story has all of the characteristics of the classic urban legend of the "vanishing hitchhiker."

Altoona is not the only county in the state that is home to this type of apparition. Berks County has its own Lady in White. This account originated several decades ago with a local police officer who was coming home from Reading as the sun was going down. He saw a lady who seemed to glow standing on the side of Pricetown Road. The officer slowed his car down when he came within about twenty feet of her. There was an intersection right before he was about to pass the lady, but in the second he checked for any oncoming cars, the lady vanished.

Many other counties across Pennsylvania have rumors or reports about Ladies in White. On April 25, 1925, in Schuylkill County, Claude and Mary Duncan were hiking on Broad Mountain. As they walked along the road, they saw a flock of crows circling an area nearby. The two hikers went to see what had died. To their horror, they saw a burned-out clearing with the burned corpse of a young woman in the center of it. Her murderer was never identified or apprehended. Since the removal of her body, dozens have reported a bright white apparition roaming the woods near the clearing. The ghost is said to be the shape of a girl traveling in circles as if she were lost.

Lehigh Valley has a Lady in White that is known to walk the canal and float on top of the water in the late light of the moon. The Luzerne County Courthouse is allegedly home to a White Lady that hangs around the second

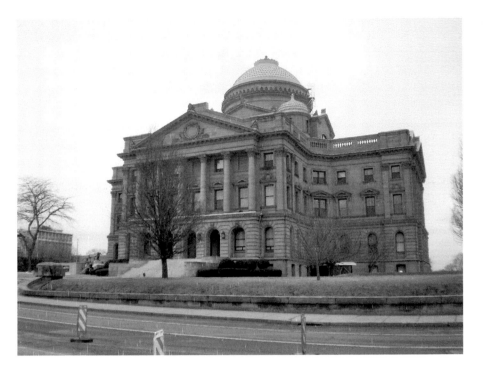

The Luzerne County Courthouse is allegedly haunted by a Lady in White. *Courtesy of Rachael Gerstein.*

floor terrifying employees. At the Jarrettown Hotel in Montgomery County, many customers have stated that a beautiful Lady in White stands in the upstairs window, only to disappear when you go upstairs to look for her.

In Port Vue, Allegheny County, the ghost of a Lady in White has been witnessed wandering in Calvary Cemetery. The ghost is said to be of a woman who froze to death near a tombstone while waiting for her lover, who never arrived. He had been mugged when he left work at a nearby mine and was prevented from meeting with her. The loyal woman waited until it was too late, and her ghost is said to wander the cemetery, still waiting. Indiana, Blair, Bedford, Lehigh, Delaware, Franklin and Erie Counties are all home to similar versions of the Lady in White.

So what do these stories of the Lady in White mean? Each version focuses on a tragedy befalling a beautiful young woman. Some of the legends, like the Buckhorn/Wopsy Mountain tale, are linked to locations that can actually be very dangerous if one is not careful. In that way, some of the stories are conveying an element of caution. Other versions of the White

Lady are linked to places where real tragedies have occurred, and even though the details of the true incidents are often changed dramatically in the legend, the stories show that the community remembers the tragedy in the telling of the supernatural tales. The Lady in White resonates with young people especially, because she was also young, and her life was cut short in an unanticipated way. No one can escape death, but the presence of the ghost shows that there is something beyond the physical end.

SOURCES

Adams, Charles J., III. *Berks the Bizarre*. Reading, PA: Exeter House Books, 1995.

————. *Luzerne and Lackawanna Counties Ghosts, Legends & Lore*. Reading, PA: Exeter Houser Books, 2007.

————. *Montgomery County Ghost Stories*. Reading, PA: Exeter House Books, 2000.

Adams, Charles J., III, with David Siebold. *Ghost Stories of the Lehigh Valley*. Reading, PA: Exeter House Books, 1993.

Brunvand, Jan Harold. *The Vanishing Hitchhike: American Urban Legends & Their Meaning*. New York: W.W. Norton & Company, 1981.

Haughton, Brian. *Lore of the Ghost: The Origins of the Most Famous Ghost Stories Throughout the World*. Franklin Lakes, NJ: New Page Books, 2009.

Jeffrey, Adi-Kent Thomas. *Ghosts in the Valley: True Hauntings of the Delaware Valley*. New Hope, PA: New Hope Art Shop, 1971.

"The Legend of the White Lady of Wopsy Mountain." http://www.pennsylvania-mountains-of-attractions.com/whiteladyofwopsy.html.

Nesbitt, Mark, and Patty Wilson. *Haunted Pennsylvania: Ghosts and Strange Phenomena of the Keystone State*. Mechanicsburg, PA: Stackpole Books, 2006.

Puglia, David J. *South Central Pennsylvania Legends and Lore*. Charleston, SC: The History Press, 2012.

"Wopsononock: A Brief History." http://www.wopsylady.webs.com/history.htm.

HAUNTED LIBRARIES OF PENNSYLVANIA

Elizabeth Williams-Herrman

Some of you may remember the scene from the 1984 comedy *Ghostbusters*, where the Ghostbusters were hired to capture a ghost who had been terrorizing both staff and patrons at the New York City Public Library. While the scene in the movie is meant to be funny as the Ghostbusters bumble their way through the event, there have been many who claim to have had real paranormal experiences in libraries throughout the United States. To many, libraries seem to be the ideal place for paranormal occurrences due to the fact that most are housed in old buildings filled with their own unique histories. There are actually many libraries throughout the state of Pennsylvania alone that are purportedly home to ghosts. Because of their number, they all cannot be discussed here, but I will examine the four most popular Pennsylvania library hauntings.

The Mansfield University's North Hall Library, Pennsylvania State University's Pattee Library, the Andrew Bayne Memorial Library and the Easton Public Library all have alleged supernatural occurrences that are attributed to notable women in their communities. Two of these women, Amanda Bayne Balph and Elizabeth Morgan, who are believed to haunt the Andrew Bayne Memorial Library and the Easton Public Library, respectively, lived to ripe old ages and contributed greatly to their communities. On the other hand, the two college-age women who are said to haunt their university's libraries, Betsy Aardsma (Pennsylvania State University) and a woman known only as Sarah (Mansfield University), are noted more for the tragedies that cut their lives short, leaving their spirits behind to roam the site of their demise.

College hauntings are usually very different from other types of ghost stories. These stories were (and for the most part, still are) passed from staff to staff and student to student. This was especially true before the Internet made the dissemination of ghost stories much easier. This oral tradition, coupled with the very nature of college life (the transient nature of the storytellers) makes it easier for details to get lost or fuzzy with each passing generation of students. Often, college ghost stories serve a purpose beyond scaring freshmen, whether that purpose is to memorialize a person or event, celebrate the school's history or to provide a morality tale disguised as a ghost story. Some stories fall in more than one of those categories, of course, such as Mansfield University's Sarah.

Mansfield University, located in the small northern Pennsylvania town of Mansfield, has been educating students since before the American Civil War. It was founded in 1857 as Mansfield Classical Seminary and its history is closely intertwined with the town it calls home. The borough of Mansfield and Mansfield University were both incorporated in the same year. As of 2014, Mansfield University boasts an undergraduate population of a little over 2,800, according to *U.S. News and World Report*.

Undoubtedly, most of those students already know the story of Sarah, the ghost of the North Hall Library, which is the school's most pervasive ghost story. North Hall has been the school's library since 1996. However, it was originally built as a women's dormitory in 1874 and expanded in the late 1800s through the early 1900s. It was during this renovation that a seventy-foot-high atrium known as "the well" was added to the North Hall dormitory. Although the well was boarded up in the 1940s because it was a fire hazard, North Hall continued to function as a women's dormitory until 1976, and parts of it had been converted to office space throughout the years. From 1982 to 1996, the building was abandoned completely and then reopened as the school's library. Beginning in the 1950s, many have claimed to have had strange experiences in North Hall.

William A. Kovlacik Jr. describes the legend of Sarah in a 2006 article titled "The Ghost of Every Floor: Sarah Still Haunts Mansfield University Library Untold Years Later." In the article, Kovlacik says, "Every university has its ghost stories and unifying myths, but Mansfield's ghost story IS its primary myth and a remarkably enduring one at that." According to Kovlacik, a version of the legend is even told to students at freshmen orientation. However, who Sarah was when she lived and how she met her end differ depending on the teller. Every version of Sarah's story agrees on one point: that she was a pretty young woman who called North Hall her

home away from home. Beyond that, the stories differ wildly. Most believe she was a student in the 1930s, although some claim it was the 1880s.

One version (the university's favorite, according to Kovlacik) describes her as an extremely gifted music student who was sitting on the railing on the top floor of the North Hall singing the school's alma mater. Her dorm mates, moved by the beauty of her voice, poured from their rooms to listen. Sarah sang with such emotion and passion that she lost her balance and fell to her death. While the other girls screamed in horror, Sarah continued to sing as she fell. In this version, her imprint occasionally appears on the floor where she died and moves in rhythm with the school's alma mater.

Most students, however, prefer a darker, albeit more believable version of a suicidal young woman who jumped from the top floor of her dormitory. Although the reasons why differ, most versions believe that it stemmed from some type of altercation with her boyfriend. Some stories claim she was pregnant and despondent because the baby's father rejected her. Others say it was because he jilted her—instead of showing up for their date, he sent a note telling her he no longer loved her—while others say that he broke off their engagement shortly before their planned Christmas wedding. One version claims her boyfriend was expelled from school and could not face her, while others believe that he wasn't her boyfriend at all, but that a young man's rejection of her advances caused her to take the fatal plunge. Yet another version places the date of Sarah's death during the First World War, saying that she committed suicide after discovering that her fiancé died in the war.

Regardless of which version of the story a person hears or chooses to believe, several generations of students, professors and staff members have attempted to discover the truth behind the legend of Sarah, which was spurred on by reports of paranormal activity from those who have lived and worked in the building. To date, no one has been able to uncover any information as to who Sarah was or the how and why she died. No newspaper articles have been found, and there are no university records relating to Sarah's death (although it is important to note that there does not seem to have been a name attached to the ghost of North Hall until the 1980s).

One of Kolacik's key sources in writing his article was Bonnie Kyofski, who began as a student at Mansfield and later became Mansfield's director of alumni. During her tenure at the university, Kyofski would search for evidence of Sarah. As the alumni director, she would often interview alumni who had attended Mansfield in the 1930s and ask if they knew anything of Sarah and her untimely demise. Unfortunately, all of her inquiries yielded

nothing. However, Kyofski does believe that the legend began in the 1950s in an effort to explain why the well had been boarded up. (In reality, though, the well was a fire hazard; an updraft from the well could easily feed and spread a small fire, causing the entire building to burn too quickly for students to escape.) She told Kolacik, "I am not denying that there are spirits there. After all, it was a woman's dorm for one hundred years, with all the pain and happiness and everything that goes along with that. I just don't think 'Sarah' is one of the spirits." Steve Disaparra, founder and leader of Ghost Hunters of South Tioga, Pennsylvania (GHOST–PA) who investigated the library, believes that the name Sarah became attached to the North Hall ghost because of Sarah A. Woodruff, who graduated from the school in 1866 (before North Hall had been built) and died one month later.

The lack of evidence has not stopped the legend from spreading among generations of Mansfield students, nor has it stopped students and staff members from experiencing unexplained events. Some people have claimed that the university covered up the girl's death, spreading the story that she had taken ill and had gone home instead of admitting to her death. Reportedly, girls who had lived in the dormitory heard music coming from locked rooms and felt unexplained gusts of wind. Two students who had volunteered to help sort through books and shelve them in the new (empty) library one night reported that books sprang off the shelves. Since the library opened, others have reported books mysteriously flying off shelves. A few people have even claimed to see a ghost. Her appearance differs in the accounts. Some say she's in Victorian-era clothing, while others say she's in a long white nightgown or wedding dress. Most of the time, she is carrying either a candle or an oil lamp. Students also reported seeing shadows in empty, brightly lit hallways. On the outside of the building, some have seen her figure peering out the windows.

Over the years, a few girls have even claimed to have been in touch with the ghost. She allegedly chooses certain girls to make contact with, telling them where to find information about her and the school's cover-up. Most students or staff who have had contact with her claim that she is friendly and only wants to help current students. Folklorist Dr. James York Glimm relates the story of a girl named Kyle, a freshman in 1975, who was one of the last students to live in the dormitory before it was condemned. Kyle claimed to talk with the ghost who told her when to come up to the seventh floor, where the ghost used to live.

A 1982 article written by student James Craft, which does not name the ghost of North Hall, was published in the *Flashlight*, Mansfield University's

student newspaper. The article relates the story of a student named "Karen" who was a theater arts major in 1978. Although North Hall was no longer a dormitory at that time, Karen allegedly visited several rooms, including those thought to have been Sarah's, as well as the old music rooms. While there, she claimed an unseen force physically restrained her, not allowing her to pass certain points in each room. Karen believed herself to have been visited by the ghost of North Hall in her dorm room, feeling her presence and smelling her perfume even after the ghost had left the room.

Craft's article says that some students believe that they saw either ghostly white lights or the ghost herself peering out of the windows on the top floor of the building from a specific spot on certain nights. Craft also put forth the idea that the ghost is not alone. The upper floors of the building are also haunted by another girl who committed suicide in her dormitory room. You can supposedly hear her sobbing and rocking in a chair in the room where she died. Matilda, yet another unfortunate student who drowned herself after learning her fiancé had died, was also said to haunt the building.

More recently, two paranormal groups have investigated North Hall. The first investigation was in 2001 when the Central Pennsylvania Paranormal Research Association (CPPRA) based out of Danville, Pennsylvania, was allowed to spend twenty-four hours in the library over the university's winter break. Psychic Josette Burrows, who claimed to have had no prior knowledge of the legends surrounding the building, identified Sarah as the building's dominant ghost. Sarah, according to Burrows, had committed suicide because she was pregnant. Orbs appear in some of the group's photographs, and a female voice is allegedly heard on one of the group's audio tapes responding, "never, never, never" when Burrows asked if she was ever going to leave. Another investigator, Kevin Triscavage, claimed to have seen an apparition of the girl, although he was too stunned to take a photograph of her. Also, members of GHOST–PA, which investigated the university in 2008, believe that some of the paranormal experiences in the library can be explained scientifically. For example, many paranormal investigators believe that people sensitive to electromagnetic frequencies, or EMF, which are produced by a building's wiring, are more likely to have paranormal experiences, particularly if they already believe the building is haunted. However, during their investigation, the group did experience some occurrences, such as hearing footsteps in empty areas, which they could not explain away.

Unlike the story of Sarah, Pattee Library's history is marred by an all-too-recent tragedy. Pennsylvania State University, founded in 1855, consists of

a main campus located in State College, Pennsylvania, and several satellite campuses. Like most universities, Penn State's main campus has its share of ghostly lore associated with many of its buildings, but perhaps none is more famous than the lore surrounding Pattee Library.

In November 1969, Betsy Aardsma was a bright, pretty, twenty-two-year-old graduate student majoring in English. She had only been at Penn State a few months, having graduated from the University of Michigan with honors earlier that year. Although she had planned to join the Peace Corps after receiving her bachelor's degree, she chose instead to follow her boyfriend, David Wright, to Pennsylvania. He had been accepted into Penn State's College of Medicine, located in Hershey, Pennsylvania. In the United States, 1969 was an extremely bloody year—the Manson family and the Zodiac Killer were active in California, and the "Co-Ed Killer," John Norman Collins, was targeting young women in Ann Arbor, around the University of Michigan. For these reasons, Betsy's family was relieved that she chose to leave the state for the presumed safety of Pennsylvania.

Instead of returning to Michigan for Thanksgiving (November 27) that year, Betsy chose to stay in Pennsylvania, traveling from State College to Hershey by bus to spend the holiday with Wright and other medical students who did not make it home for the holiday. Although Aardsma and Wright had discussed her staying the weekend, she decided to return to campus instead, saying that she had a lot of work to finish.

The next day, Friday, November 28, she and her roommate left for Pattee Library around 3:50 that afternoon, parting ways once they had reached the building. Betsy went to see a professor, whose office was located in the library's basement, before heading to the card catalogue to locate the books she would need to finish a research paper she was working on. Between 4:30 and 4:45, she was in a relatively isolated area of the large library on the Level 2 core. She was looking for books in rows 50 and 51.

Nine people were within seventy feet of rows 50 and 51, although Betsy was obscured from view because of the layout of the shelves. Some would later remember hearing a noise, which they described as a gasp and then books falling. Mary Erdley, a student who had known Betsy, got up to investigate the noise when two men confronted her and said, "Somebody had better go help that girl." They took her to where Betsy lay and left. Erdley tried to get help from passing students, but it was another fifteen to twenty minutes before anyone stopped to help. A library employee called Ritenour Student Health Center, which was close to the library, as another librarian tried to give Betsy mouth-to-mouth resuscitation. An ambulance

arrived, although the ambulance attendants assumed that Betsy simply had a seizure. It was not until Betsy's body arrived at the student health center that the awful truth was discovered—Betsy Aardsma had been murdered. She was declared dead at 5:50 that evening.

Betsy's autopsy report said that she was stabbed in the breastbone with a "hunting-style knife with a one-edged blade 3½ to 4 inches long." The killer sunk the blade so deep into her chest that it severed her pulmonary artery and penetrated her heart. It was the perfect kill wound, and she was dead within minutes. She bled mostly into her lungs; what little blood exited her body was not immediately apparent because she was wearing a red dress. Dr. Thomas Magnani, the Centre County pathologist, wrote that he believed she was attacked during a face-to-face confrontation; however, investigators believe she might have been grabbed from behind, perhaps in an attempt to explain why she didn't scream or try to defend herself. Witnesses claim that the rows in that section of the library are tightly packed together, and the space between them is so narrow that it would be hard for two people to stand side by side. Also, in the late 1960s, the shelves extended all the way to the walls, so there would have been no escape for Betsy had she tried.

Pennsylvania State Police investigated her case for weeks, assigning forty troopers and setting up a temporary office on campus. They interviewed thousands of people using a variety of methods, including polygraph tests, as well as less-conventional methods like hypnosis. No weapon was ever found; the killer presumably took it with him or her. Unfortunately, Penn State inadvertently compromised the crime scene, hindering the investigation. After she was stabbed, Betsy urinated, and a janitor cleaned it before realizing that the stacks were a crime scene. Her murderer was never found, and the case still remains an open cold case with the Pennsylvania State Police.

Although police believe it to have been a prank, a shrine to Betsy Aardsma appeared in 1994 (the twenty-fifth anniversary of the murder) in the stacks where she was killed. Someone left a lit candle with the message "R.I.P. Betsy Aardsma, born July 11, 1947, died November 28, 1969. I'm back" written on the floor in a red marker. Nearby librarians found newspaper clippings, which were contemporary with the murder. Another shrine was found elsewhere in the library in 1999.

Even today, the case still attracts a lot of attention. Around the anniversary, Pennsylvania newspapers will run articles on Betsy's murder. Centre County district attorney Michael Maderia told the *Pittsburgh Post-Gazette* in 2009, "It sounds like an urban legend…except it's real." The Internet has breathed

new life into the case as well, with amateur detectives and ghost hunters discussing it. Many Penn State students have heard of the murder, and some believe that Betsy Aardsma never left the library.

According to *Haunted Pennsylvania: Ghosts and Strange Phenomena of the Keystone State*, a 2008 book written by Mark Nesbitt and Patty Wilson, shortly after the murder, people began to hear a scream come from the stacks. Others have reported actually seeing the young woman in the stacks where Betsy was killed. Ryan Buell, star of the ghost hunting show *Paranormal State* and a Penn State alum, claimed in 2006 to constantly get reports of paranormal activity in Pattee Library—mostly from women who feel like they have been attacked by something they could not see. He also reported that people have seen shadowy figures walking through walls where doors or halls used to be.

Another former Penn State student, Grace Shin, who was a sophomore in 1998 when she was interviewed by a reporter for the *Daily Collegian*, claimed to have had a paranormal experience in the library. She said, "My friend and I were looking through Satanic stuff in the occult section of the library when I felt someone touch me on the back of my neck… None of my friends or anyone else was in the aisle when I turned around and the timer made the lights in the aisle go off and I booked it out of there." She reported that she believed whatever touched her in the library might have followed her back to her dorm room because that night she woke up paralyzed, with a soaking wet pillow. She said that she felt like she was crying. It is very likely that at least the experience was due to sleep paralysis, a frightening, but surprisingly common condition. Sufferers from the condition feel like they are awake but are unable to move. Some have reported feelings of stress or as if they are being watched, while others have had full-on hallucinations.

It is important to note that many others who have studied the case dismiss the idea that Pattee Library could be haunted. Tommy Davis, a student who has thoroughly researched Betsy's life and murder in order to write and produce a docu-drama on the case called *Betsy*, also dismisses the notion that the library could be haunted. He told *Onward State*, a Penn State news blog, in 2013 that rumors of a haunting are "ridiculous…I can almost guarantee I've spent more time in the stacks than 99.9 percent of the people who study there…It's a contrived legend that's grown. In my mind it's a tragic story, not a horror story. People say they hear screams and see blood. There weren't screams during the murder and there was no visible blood." Sascha Skucek, a Penn State alumni and professor at the school, believes, "A ghost would

be trapped in the library for a reason…There's no reason for Betsy to be trapped." Skucek believes that it is important not to get hung up on the ghost story, as it detracts from the facts of the case.

A different type of haunted library legend has its roots in the early 1900s when the citizens of Easton (located in Northampton County) found the perfect spot to build their new public library. Unfortunately, the land was already occupied—by the dead. It was the location of one of the city's oldest cemeteries and the final resting place of some of its most prominent residents. In what could be the plot of a 1980s horror movie, construction continued and eventually led to the unearthing of 514 graves. The sight was reportedly a bit gruesome. Some of the coffins had split open, resulting in some body parts that had been separated from the bodies they belonged to.

While most of the cemetery's former residents were identified and claimed by family members who saw to their reburial, approximately thirty bodies were never claimed. Unclaimed and unidentified bodies, as well as unattached limbs, were reburied in a mass grave—a vault under what is currently the northeast driveway (land that has been sinking and settling ever since the grave was added). Two prominent former residents of the town were reburied in marked graves on the library's property. William Parsons, a surveyor who helped lay out the city, was interred by the library's main entrance, while Elizabeth "Mammy" Bell Morgan was reburied in the west lawn.

Elizabeth had been a truly remarkable and interesting figure in the city's history. She was born to Quaker parents in the 1750s. In the 1770s, her parents opposed her relationship with Hugh Bay, a grocer and Revolutionary War soldier. They sent her to Europe to complete her education in the hopes that she would forget him. When she returned four years later, she married Bay and was expelled from her Quaker congregation. Unfortunately, Bay died three years after they were married, leaving Elizabeth a widowed mother to a young daughter.

Six years later, she married again, this time to Dr. Abel Morgan, who had been a surgeon in the war. Abel relocated his family to the Leigh Hills when a yellow fever epidemic hit Philadelphia. Once his wife and children were settled, he returned to the city, only to contract the disease himself and die shortly after his return. Elizabeth was not notified of his passing until she traveled to Philadelphia months later to find out why she had not heard from him. With little left for her in the city of her birth, she relocated to Easton permanently. There she purchased the hotel she had been living in and became renowned for her intelligence, particularly in matters of the law.

Abel had owned a collection of law books, which his wife, after his death, studied thoroughly. Soon neighbors were coming to her asking for legal advice and to settle disputes between them. Although she faced opposition from men in the town who were in the legal profession, she continued to operate in this capacity for the town that she loved until her 1839 death at the age of eighty.

There are some who believe, however, that death did not stop Elizabeth from making her presence known after the library was built. Some claim to have seen her walking the grounds. Several other disturbances have been reported throughout the library, including books falling to the floor seemingly of their own accord. Filing cabinets within the library have reportedly opened and closed on their own. People claim to have been touched, although they were alone at the time. In the past, some staff members have heard doors open and slam shut on their own when the library was closed. It is odd that most of these occurrences have been attributed to Elizabeth, given the unmarked mass grave on the library's property. Perhaps it is because every good ghost story needs a name attached to it. Or perhaps it is the city's way of keeping the memory of the remarkable Elizabeth Morgan alive after all these years.

Nestled in Bellevue Borough, just outside of Pittsburgh, Pennsylvania, the Andrew Bayne Memorial Library is housed in a mansion that was built in 1875. The library's namesake, Andrew Bayne, had been one of Allegheny County's most prominent citizens. He was a member of the Pennsylvania Constitutional Convention who was elected the county's sheriff in 1838. The mansion was built for his daughter, Amanda Bayne Balph, by her architect husband, James Madison Balph. When Amanda died childless in 1912, she bequeathed the four-acre plot and the mansion to the borough with the stipulation that it be used as a library and a park. In accordance with her request, the library opened in 1914, a tribute to not only Amanda but also to her father. Some believe, however, that Amanda's spirit continues to occupy her former home.

Former library director Sharon Helfrich told Pittsburgh's *Tribune Review* in 2005, "People talked about it being haunted, but I just thought, 'Right, it's a big old Victorian house so people automatically think it must have spirits living in it...But then I saw some pretty strange things happening." Many believe that Amanda chose to make her presence particularly known in 1998 when the elm tree called the "Lone Sentinel" had its branches removed and its trunk shortened. Amanda had specified in her will that none of the trees on the property could be removed; however, the two-

The Andrew Bayne Memorial Library in Bellevue, Pennsylvania. *Editor's collection.*

hundred-year-old elm was suffering from age and disease and could not be saved. Librarian Linda Momper recalled in 2003 that it was during this time, while alone in the library, she saw "a woman's torso clad in dark clothing reflected in one of the bay windows. I dismissed it as imagination

and continued on with my work for a minute, then turned again to the window. The reflection remained. Three times I did this, and three times the image was evident. The fourth time I checked, it was gone." Helfrich, too, saw something strange in the library during this time. She was alone in a small room filing papers after hours when the library should have been empty. She saw a dark figure glide past her and continue down the hall before disappearing. Others reported seeing a woman dressed in Victorian clothes appear in Amanda's bedroom window.

There are also reports of the two computers behind the front desk behaving oddly while work was being done on the tree. Helfrich said, "I was working at one...alone behind the desk, I heard what sounded like a scanning noise. As I looked at the second computer's monitor, numbers appeared there. Then just as mysteriously as it started, it stopped. This happened often during this period...My opinion is that Amanda was unhappy about the tree and her spirit was restless." Odd occurrences have continued to plague the library even after the Lone Sentinel was removed. Reports of strange, unexplained noises continue, and lights and fans will occasionally turn on without explanation.

Helfrich recalled one such occasion for the *Pittsburgh Post-Gazette* in 2003. She told the paper that a few years before, the library was hosting a movie night on the library's lawn. The equipment that they used to show the movie was new and had been in working order previously. However, it simply stopped working. Helfrich looked up and noticed the attic light was on (although she was sure it had been off and no one was in the library). On her way up the steps to investigate, she promised Amanda she would not be angry with her for turning the lights on if she would let the DVD player work. When Helfrich returned to the lawn, everything worked perfectly, and the building's lights stayed off the rest of the night.

Lights turning themselves on is not the only strange electrical occurrence in the library. According to teacher Debbie Scigliano, one year around Halloween, a group of first-graders had gathered in the library for a children's program. They sat in an upstairs room and listened to spooky stories before being allowed to choose books to take out of the library. During the story-time portion of the event, the overhead fan turned on, chilling the room. Scigilano did not want to alarm the children, so she allowed it to stay on throughout the story time, making sure to turn it off when she left the room. When they returned to gather their coats, the fan turned on again. This is apparently not unusual, and some library employees believe that this was Amanda showing her approval for children's programs.

Some people believe that the Bayne Library is haunted by its former owner, Amanda Bayne Balph. *Editor's collection.*

It is perhaps a comforting thought for some that even from beyond the grave their kind benefactor approves of what they have done with the library. For those who believe, she is considered an overall friendly spirit. Talking about the strange occurrences that have happened there serve to keep Amanda and her gift alive in the community's memory. Community memory also serves as a unifying thread for all of these stories. Sarah serves as a cautionary tale and a memorial to how life was not only at Mansfield but in the community as a whole. Although the details might be fuzzy as they are passed from student to student, tales of Pattee Library's ghost have kept the memory of poor Betsy Aardsma alive for generations of Penn State students. Elizabeth Morgan is also remembered by the community through the stories told about her ghost. However, it is important, especially in the age of the Internet, when ghost stories can spread so rapidly and so far, to not lose sight of the fact that these ghosts were once living, breathing women. The details of their lives, not just their afterlives, deserve to be remembered as well.

SOURCES

Albert, Millie. "Victorian Visitor: Is the Lady of the House Now the Lady of the Library?" *Pittsburgh Post-Gazette*, October 29, 2003.

Barrett, Kay, and Jennifer Beaver. "Paranormal Activity Investigated in North Hall." *Flashlight*, October 9, 2008.

Boyer, Lauren. "Penn State Legends Uncovered." *Daily Collegian*, August 9, 2006.

Burkhart, Gregory. "Murdered Student's Ghost Believed to Haunt Penn State Library." http://www.fearnet.com/news/news-article/murdered-students-ghost-believed-haunt-penn-state-library.

Craft, James. "North Hall Ghost—Fact or Fantasy." *Flashlight*, February 25, 1982.

Curtis, Jamie. "North Hall: Three Centuries of Education." http://www.mansfield.edu/150/history-of-campus-buildings/north-hall.

DeKok, David. "A 39-year Mystery: The Murder of Betsy Aardmsa." *Patriot News*, December 7, 2008.

Desiderio, Sarah. "Forty Four Years Later, Betsy Aardsma Ghost Stories Still Resonate." *Onward State*. https://onwardstate.com/2013/11/29/forty-four-years-later-betsy-aardsma-ghost-stories-still-resonate.

Georgiou, Christina. "Easton History: Who Was Mammy Morgan?" *The Easton Eccentric*. http://eastoneccentric.blogspot.com/2012/10/easton-history-who-was-mammy-morgan.html.

Glimm, James York. *Flatlanders and Ridgerunners: Folktales from the Mountains of Northern Pennsylvania*. Pittsburgh, PA: University of Pittsburgh Press, 1983.

Hay, Bryan. "Library Haunted by Grave Past: Spirited Happenings Don't Faze Staff." *Morning Call*, October 25, 1987.

Kovlacik, William, Jr. "The Ghost of Every Floor: Sarah Still Haunts MU Library Untold Years Later." *Mountain Home*, October 2006.

LaRussa, Tony. "Ghostly Happenings: Haunted Library." *Pittsburgh Tribune Review*, October 20, 2005.

Nesbitt, Mark, and Patty Wilson. *Haunted Pennsylvania: Ghosts and Strange Phenomena of the Keystone State*. Mechanicsburg, PA: Stackpole Books, 2006.

North Hall Library, Mansfield University. "Sarah's Page." http://mansfield.libguides.com/content.php?pid=199624&sid=2964011.

Ove, Torsten. "Mystery of the Girl in the Stacks Continues to Intrigue Public: Trooper Still on Trail of 1969 Penn State Murder." *Pittsburgh Post-Gazette*, October 25, 2009.

Swindells, Scott. "The Ghosts that Haunt Us." *Daily Collegian*, October 30, 1998.

PART II
MONSTERS

THERE'S SOMETHING OUT THERE IN THE DARK

Anthropologist David D. Gilmore wrote, "The mind needs monsters. Monsters embody all that is dangerous and horrible in the human imagination." This is true. Monsters are the vehicles by which every dark part of the human mind can be brought to light without individual consequence. Monsters embody the things that society as a whole is afraid of and the things that haunt individuals in their own minds. Though their forms change through time, monsters always present pressing yet almost incomprehensible threats, playing on our darkest fears. At the same time, people often identify with monsters because they exist beyond the confines of society, performing acts that are forbidden.

Monsters have evolved through time to keep pace with contemporary fears. In the Middle Ages and early modern Europe, the most horrific monsters seemed to be part-man and part-beast, such as the werewolf. These unnatural creatures were affronts to God's design for nature and were assumed to have spawned by some trickery of the devil. For colonists in early America, a monster might be one who has left the small towns and bastions of civilization to dwell in the wilderness, like the "savage" and demonized Indians. Such is the case with the Ape-Boy of the Chester Swamps. In our modern age, monsters often take the form of some type of technological

terror. Technology is our great double-edged sword, helpful yet often dehumanizing. Though it is responsible for many great advances, it can also be used for great destruction. An example of such a monstrous threat would be UFOs piloted by alien beings with technology so advanced that there could be no defense.

Monsters are traditionally encountered in what folklorists would call liminal areas. Such areas can be considered "spaces between." Elizabeth Tucker referred to them, in the context of hauntings, as "neither uninhabitable nor fully inhabited." These are places that represent physical, mental or social boundaries—the edge of the wilderness, an isolated road, the surface of a dark lake. It is in these areas of uncertainty where monsters dwell, and it is in these very same areas that they are encountered.

The following essays describe a few of Pennsylvania's monsters. Some are carry-overs from Europe. Others emerged here in the new world in its seemingly endless wilderness. We will begin with the vast lake known as Erie, where something is said to stir underneath its dark and often dangerous waters.

THE LAKE ERIE SEA SERPENT: TWO HUNDRED YEARS OF SIGHTINGS

Stephanie Hoover

At least twenty states are home to reported lake monsters. Pennsylvania is one of those rare states that boasts not one but two creatures: the cryptid supposedly inhabiting Raystown Lake in Huntingdon County (generally considered a hoax perpetrated by clever marketing minds) and South Bay Bessie, an elusive serpent first spotted in the early years of the nineteenth century.

Unlike Scotland's Loch Ness, Lake Erie is far too young to shelter a prehistoric water giant leftover from the dinosaur days. Initially formed twelve thousand years ago, Lake Erie has only been a stabilized landmass for the last third of its existence. Stretching 240 miles in length, Lake Erie is much longer than Nessie's home in Scotland but, at just sixty-two feet, has a far more shallow average depth. Yet while its size and age may be limited, there are no such constraints on the magnitude of the tales reported by Lake Erie's boaters, tourists and residents.

According to C.S. Rafinesque in his *Dissertation on Water Snakes, Sea Snakes, and Sea Serpents*, the first mention of a monster in Lake Erie came in 1817. On July 3 of that year, the crew of a schooner reported seeing a creature thirty-five to forty feet long and a foot around. It was so dark mahogany in color that it almost appeared black. No details were offered by the witnesses with regard to the presence of scales, so it is unclear whether the creature was of the snake or fish variety.

In 1854, fishermen on the eastern side of the lake reported a serpentine form moving about the water with great agility. Like the earlier monster, this

A sketch of a sea serpent that appeared in *A Romance of the Sea Serpent: or, the Icthyosaurus* by Eugene Batchelder in 1849. *Courtesy of Stephanie Hoover.*

one was estimated at nearly forty feet in length. Seven years later, another party of fishermen in this same region of Lake Erie came so close to a sixteen-foot serpent that they were able to fully inspect it. They described the thing as greenish with an erect head and tail.

In 1887, the Dusseau brothers, returning from a day of fishing, spotted a "phosphorescent mass" on the beach. They quickly made their way to the shore only to find the creature in its death throes. Although somewhat like a sturgeon in size, the brothers said the creature also possessed arms that it threw wildly from side to side. They ran for help and rope to capture the creature but, upon their return, found only marks on the beach indicating where it had lain. Apparently, while tossing itself about, the thing tumbled back into the water and was carried off by the waves. Before disappearing, however, the sea monster cast off scales the size of silver dollars.

Lake Erie's sea serpents were particularly active in the 1890s. Two fishermen spotted a twenty-five-foot-long creature in May 1892. An estimated eighteen inches in diameter, the huge water snake propelled itself using flippers located about five feet behind its large, flat head. It was black with brown, mottled spots. In the fall of this same year, schooner captain Patrick Woods was making his way from Buffalo to Toledo when, about a half mile in front of him, he saw the otherwise calm water of the lake violently whipping into foam. As he neared the spot, he saw a huge sea serpent desperately fighting off an invisible underwater attacker. Woods said he could clearly see the sparkling eyes in its large head. He estimated the brown body to be fifty feet long and nearly four feet in diameter with a head rising four feet out of the water.

In October 1894, on the New York shore of Lake Erie, a creature was reported by a witness seemingly beyond reproach: the Reverend Alex Watt of the Silver Creek Baptist Church. Watt, his wife and a friend were enjoying the sunset from the beach when they heard, then saw, a churning commotion

The shore of Lake Erie at Presque Isle. *Editor's collection.*

in the water about half a mile from where they stood. A serpent, roaring through the lake at great speed, turned the waves to foam. Watt calculated the portion of the beast rising and falling along the waterline to be at least eighteen feet in length. He described fins along its back but said only three or four were visible during each undulation. Its head, said Watt, was heavier and darker than its body.

"I would not want to be in the water in a small boat if that creature decided to turn hostile," Watt assured a newspaper reporter.

A hoax perpetrated in the early 1930s had residents around Lake Erie briefly fearing an invasion of pythons. As it turned out, Clifford Wilson, the man who "captured" the python and brought it ashore, was a carnival promoter hoping to cash in on the lake monster phenomenon. It was, in fact, his own eighteen-foot-long Indian python he claimed to have hit with an oar and then wrestled into his rowboat.

Just three years after Wilson's trickery was uncovered, however, a man named Ben A. Schwartz and five of his friends were sitting on the lakeshore when they saw what they initially believed to be a dog swimming toward

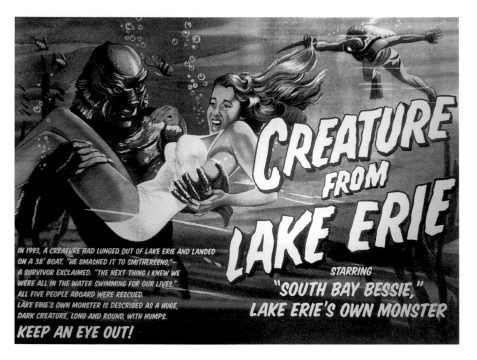

IN 1993, A CREATURE HAD LUNGED OUT OF LAKE ERIE AND LANDED ON A 38' BOAT. "HE SMASHED IT TO SMITHEREENS,"— A SURVIVOR EXCLAIMED. "THE NEXT THING I KNEW WE WERE ALL IN THE WATER SWIMMING FOR OUR LIVES." ALL FIVE PEOPLE ABOARD WERE RESCUED. LAKE ERIE'S OWN MONSTER IS DESCRIBED AS A HUGE, DARK CREATURE, LONG AND ROUND, WITH HUMPS. KEEP AN EYE OUT!

STARRING "SOUTH BAY BESSIE," LAKE ERIE'S OWN MONSTER

A humorous take on the Lake Erie monster (utilizing an old *Creature from the Black Lagoon* movie poster) at the Tom Ridge Environmental Center at Presque Isle. *Editor's collection.*

them. It was not until the creature changed direction that Schwartz realized he was looking at a gigantic snake at least twenty feet in length. The beast swam along the shoreline for about fifteen minutes before heading out into deeper water. Experts to whom the incident was reported suggested the animal might have been an escaped rock python, an African native known for eating prey as large as deer.

Sightings continued in spurts. In the early 1990s, when stories of Loch Ness were achieving worldwide media coverage, Lake Erie's sea monster also made frequent appearances. A September 1990 encounter received wide press coverage. On this occasion, a family named Bricker claimed to clearly see—from the remarkable distance of more than three football fields—a black creature about thirty-five feet in length. It held its snakelike head erect above the waterline as it traveled at a speed reportedly equaling that of the family's boat.

Following the attention received by the Brickers' story, several other witnesses swore they, too, saw the creature. One claimant was a Huron firefighter. Another was the owner of a lake shore cottage. A newspaper

editor established a toll-free number dedicated to reports of sightings of the Lake Erie sea serpent, while an enterprising marina owner offered a $5,000 reward to anyone who captured South Bay Bessie alive. He even went so far as to post an optimistic sign on his gates that read: Future Home of the Lake Erie Sea Serpent.

As of yet, no one has captured Bessie. In fact, she has been fairly dormant in the last two decades. Still, no one is ruling out the possibility of a lake monster completely. As long as humans entertain even the slightest chance that mythical beasts of the watery deep may exist, visitors to Lake Erie will scan its surface with more than ordinary diligence.

THE WEREWOLVES OF PENNSYLVANIA

Thomas White

The werewolf has long haunted the western imagination. Legends of men turning into beasts, whether literally or metaphorically, have been around since ancient times and have carried a variety of cultural meanings. Though the modern world has relegated werewolves to the role of movie monster, or even antihero in some cases, the supernatural predators were once taken more seriously and were viewed very differently than they are today. Like the vampire, much of our modern myth of the werewolf was created by film. Depictions of unfortunate souls destined to create carnage under every full moon until they are put down by a silver bullet may be entertaining but do not always hold true to the real myths that emerged in Europe over the centuries. Particularly strong in Central Europe, traditional werewolf legends made the voyage across the Atlantic with immigrants, especially the German and French immigrants who would find their way to Pennsylvania.

Recent years have seen more academic analysis of the beliefs about werewolves and of shape-shifting entities in general. While that research is beyond the scope of this publication, it is important to look at a little of the historical background to put Pennsylvania's werewolves in perspective. We must remember that even in ancient times, not everyone believed that a person literally transformed into a wolf. Sometimes a werewolf was a person who took on the feral characteristics of a wolf. The most commonly cited example of this type of transformation is the "berserker" of Northern Europe. Berserkers were Norse warriors who entered a state of frenzy

before battle, often after rubbing some type of ointment on their skin. (The ointment likely had pharmacological or hallucinogenic properties.) They would fight fiercely in battle and earn both fear and respect. It has even been suggested that the word werewolf evolved out of the Saxon term for "war wolf." Pre-Christian Northern Europe often held the wolf in high regard, and assuming its characteristics was not necessarily viewed as negative.

In Southern Europe, Greek and Roman legends and myths contained numerous references to shape-shifting humans and animals. The story of King Lycaon, who angered Zeus/Jupiter and was turned into a werewolf as punishment, is the source of the word lycanthropy. Lycanthropy is the scientific term for the belief that one can transform into a wolf, both as a psychiatric condition as well as in traditional folklore. Ideas about werewolves would change after the fall of the Roman Empire, during the Christianization of Northern Europe.

Throughout the Middle Ages and into the Renaissance, there would be an increased emphasis on the evil nature of the werewolf in Christian Europe. As theological ideas about the nature of the devil, demons and witchcraft became more defined and precise, it became clear to the observers of the time that, like that of the witch, the power of the werewolf must have come straight from the Evil One. In fact, contemporary accounts describe witches and werewolves gaining power in much the same way. Some type of pact with the devil, whether described directly or implied, was always at the root. However, the direct transformation into a wolf was not triggered by a full moon but rather the application of an ointment or salve to the skin and the wearing of a wolf hide or a wolf skin belt. Witches also were described as gaining their abilities, including flying through the air on a broom, by applying a magical ointment or salve. It was also believed that witches could change into a variety of animals, so the line between witch and werewolf was not always clear. During the period of the witch trials (the 1400s to the early 1700s), there was also a series of lesser-known werewolf trials in Central and Western Europe. There was also theological debate over whether individuals actually transformed into wolves, or if, in fact, the werewolf was a "double" of the person, created through the trickery of the devil.

Another reason that the werewolf seemed to be such an ominous threat during that time was tied to a purely practical concern—the threat of real wolves. The presence of wolves had been on the decline in Europe until the Black Death and the Wars of Religion reduced the human population and created enough destruction for the wolves to rebound. Their population increased, and the wolves were again a threat to the farmers and peasants

of Central Europe. It is precisely at that time (the 1400s through the 1600s) that the concern with werewolves reached its peak. As the wolf population again gradually declined, so did reports of actual werewolves. As one might expect, many of Pennsylvania's werewolf stories date from the late 1700s through the 1800s, a time when wolves still presented a threat to Pennsylvania farmers and frontiersmen.

Immigrants from Europe obviously transplanted their folk beliefs to Pennsylvania. The colony, under the direction of the Quaker William Penn, was tolerant of other religious groups and attracted many religious sects from Germany and Central Europe. The economic opportunities also drew many immigrants of various ethnic and religious backgrounds. Along with the flow of people and cultures, werewolves made their way into Penn's Woods, or at least into its legends. Most of the state's early werewolf legends have been lost, but luckily, state folklorist Henry W. Shoemaker recorded a sampling in the early twentieth century. Shoemaker, who was frequently a controversial figure among other folklorists for his methods and his tendency to exaggerate and sometimes fill in missing details, was a product of the Progressive Era. Focusing on rustic agricultural lore instead of urban tales, he sought out and promoted the folklore of the mountains and rural areas of Pennsylvania. In the process, he preserved the lore of the werewolf. Though it is clear that many of the details of these stories are lost to time, enough has survived to provide us with a glimpse of early Pennsylvania's beliefs about the werewolves.

Some of the most interesting werewolf tales that Shoemaker recorded were the ones that he heard first-hand as a child in Clinton County from the Quigley family. The family, which had a mixed ethnic heritage of German, Scots-Irish and northern Italian, was long established in the county and passed along their own supernatural experiences, as well as those of some of the early settlers. One of those early settlers was the rugged German frontiersman and Indian fighter Peter Pentz. As an old man, Pentz would visit the Quigley family and tell stories of the old days around the campfire. One of those stories involved a werewolf.

Pentz frequently recalled a tale involving his great-aunt Divert Mary DePo, who was a midwife living near the headwaters of Little Buffalo Creek. According to the story, DePo was out late one night at the nearby Schefflly farm assisting with a difficult childbirth. After helping to deliver triplets, she made the journey home across through the dark fields and woods on her own. As DePo approached her barnyard, what initially appeared to be a large black dog appeared in the moonlight. When the beast crossed into her

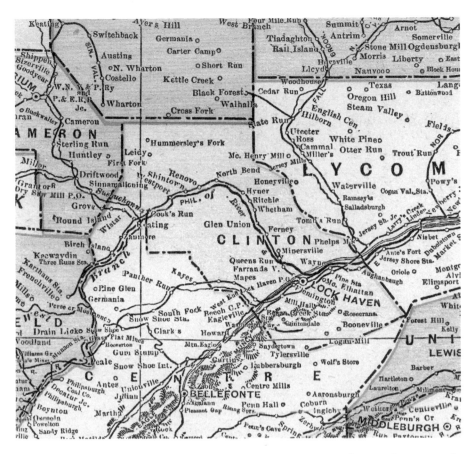

A map of Clinton County, Pennsylvania, in 1890. Several accounts of werewolves emerged from the region in the 1800s. *Editor's collection.*

path, she realized it was a wolf. As their eyes fixed on to each other, the wolf rose up on its hind legs, opened its terrifying jaws and lunged at her with its front paws. DePo scrambled away from the beast as fast as she could and ran toward her front door. She reached it before the wolf was able to catch her. As she slammed the door shut, she shouted for her sleeping husband, who sprang from the bed when he heard her cries. He grabbed his rifle while she frantically explained what had happened. Suspecting it was no ordinary wolf, he loaded his gun with two pewter bullets that had been wrapped in "sacramental," or blessed, wax. When Mr. DePo opened the door, the wolf was still close by, growling aggressively. He leveled the gun at the wolf and pulled the trigger. The beast writhed and dropped to the ground. Mr. DePo

approached cautiously, preparing to fire another shot, when he was greeted with a shocking surprise. While walking the few feet from his door to the wolf, a dramatic change had taken place. Instead of the growling beast, a neighbor was lying near death at his feet. As the man breathed his last, he thanked DePo for ending his torment.

Members of the Quigley family claimed to have had several direct experiences with werewolves in the 1800s. One year, George Quigley (the father of Jacob, Shoemaker's primary informant) frequently saw a large brown female wolf lingering around his fence line during the day. Fearing for the safety of his animals and his family and believing that there was something strange about the wolf, George decided that he needed to take action. He loaded his rifle with a silver bullet and shot the wolf in the right foreleg. The beast let out a scream that almost sounded human and ran off into the woods. Not long after, George learned that an old woman who lived in the area showed up at a neighbor's cabin that same afternoon with a gunshot wound to the right arm. She claimed that she had accidentally shot herself while fox hunting. The neighbor took care of the woman's wounds, and from that point forward, neither the wolf nor the woman came near the Quigley property again.

Something similar happened to another relative named Philip Quigley. The exact year of the incident was not recorded by Shoemaker. Over the course of several weeks, Philip's horses became more and more agitated until they reached the point where he could no longer use them. He prepared to sell them to recoup some of his losses, but his wife convinced him to wait a little longer because she believed that something unusual was behind their sudden change in temperament. That night, she loaded a rifle with silver bullets and hid outside near a shed, not far from the stable. At midnight, the woman's suspicions were confirmed. A large black wolf vaulted into the stable over the Dutch door and caused the horses to panic. Although the wolf moved too fast for her to shoot on the way in, she positioned herself to shoot it when it emerged and waited patiently. Finally, when the first rooster crowed, the wolf leapt back out of the stable. Mrs. Quigley carefully aimed and fired, striking the wolf in the jaw. The injured wolf howled and ran back into the forest. Philip later discovered that a woman who lived nearby approached a neighbor for aid the following morning. Her jaw was broken and needed to be set.

These two stories from the Quigleys demonstrate that the overlap between witchcraft, magic and werewolf legends continued in Pennsylvania. Since witchcraft in both Europe and America existed in

a primarily agricultural setting, it was commonly believed that witches would harass the livestock and other animals of farmers, striking at their very livelihood. Pennsylvania folklore is full of accounts of horses being ridden by witches. Farmers would come into their stable in the morning and discover that the horses were exhausted as if they had been riding all night. The tormented animals would then be of little use that day to a farmer. Werewolves, much like real wolves, also posed a threat to farm animals, as seen in the previous story. The werewolf in the story was not physically injuring the horses but rather frightening them like a witch.

Shoemaker recorded another story that emphasizes this connection. One of the early Clinton County families was having similar problems with their horses. Every morning, the horses were in a lather and exhausted. They also appeared to have a particular type of briar stuck to their tails. This kind of briar was found on a nearby mountaintop called Falsbarich, or Stone Mountain. It was believed to be a "witch mountain," where witches would gather certain nights of the year to hold their black Sabbaths and consort with the devil. Traditions of witch mountains were common in Europe and in other parts of Pennsylvania, especially where Germans settled. The briars and the strange condition of the horses were enough to make the family believe that an unnatural force was at work.

The farmer's wife decided to keep a close watch over the stable and try to determine exactly what was happening. Around midnight, three black wolves ran up to the stable and vaulted over the gate to get inside. After only a moment, the woman heard three eerie voices say in unison, "Here I go, clear of everybody." Immediately after, three horses jumped the gate, each one with a black wolf on its back. As the horses ran off, the woman came up with a plan. She traveled up to Falsbarich and gathered thorns from bushes that grew there. Shoemaker did not describe how, but the woman attached the thorns upright to the backs of the horses, perhaps through a saddle or blanket. She waited until the moon was full to implement her plan. The thorns were on the backs of the horses, and she waited outside with a rifle. Once again, the black wolves arrived around midnight and entered the stable. This time there was no eerie chant but instead three loud shrieks. The three wolves darted from the stable. As they ran past, the woman fired her rifle, striking one above the back leg. All three disappeared into the darkness, howling as they went. The following day, one of the farmer's neighbors sought medical help from another nearby family. She claimed to have fallen off her horse into a bed of thorns and had to have dozens of them removed from her body. Of course, the farmer and his wife knew the truth.

Shoemaker did not limit his collection of werewolf tales to Clinton County. In fact, what is probably the most well-known Pennsylvania werewolf tale occurred in Schwaben Valley in Northumberland County in the 1800s. It centered on a twelve-year-old girl of French descent named May Paul. May spent many of her days working as a shepherdess, watching over her family's sheep. Her presence in the fields attracted the attention of a strange older man who was something of an outsider in the community. Rumors claimed that the man was harboring a dark secret and that he was, in fact, a werewolf. Though May's parents probably put little stock in such tales, they were not happy that the much-older man would sit silently near May as she watched over her flock. Many of the other sheepherders in the area were having problems with wolves at the time, yet when the old man was around, the wolves stayed away. Shoemaker speculated that this was why May's parents did not try to drive him away, even though he was clearly infatuated with her.

Though May's flock seemed to be safe, those of her neighbors were not as lucky. The wolves were often so bold that they attacked in the middle of the day. Some residents began to keep watch at night with their rifles. One evening, under the light of the moon, one of these men watched an old wolf cross the road. He raised his gun and fired, striking the beast. It ran off, and the man returned in the light of the morning to track the wolf by following the blood trail. At the time, a twenty-five-dollar bounty was being paid for every wolf that was shot, and he wanted to collect. The man was surprised when the blood trail led him not to a wolf, but to the old man who was in love with May. His body was sprawled on the ground, shot straight through the heart. The man noted that the old man's body had hair on the palms of the hands, the bottom of the feet and on his ears. He also possessed long, wolf-like teeth. The man buried the body on the site where he found it. The locals would eventually call that location *"die Woolf man's grob,"* or the wolf man's grave.

In the years after, May Paul claimed that the old man still came to visit her, even though no one could see him. The ghost would sit on the same log that he did when he was alive. Even after the old man's death, not a single sheep in her flock was harmed by a wolf. Some people came to believe that the ghost of the werewolf really was still protecting May and her flock.

In 1924, Shoemaker met an old man in Frenchville, Clearfield County, named Desire Billotte. Billotte was born in 1840 and could still recall stories of wolf hunts and werewolves from the mid-1800s. He told Shoemaker that even though werewolves were rare, there had been a few in the vicinity of Frenchville over the years. One could identify them by the hair on the

palms of their hands and the flatness of their fingers. Much like our modern version of the werewolf, he claimed they would change under a full moon. Such men would follow and attack humans and kill any dog that came near them. Like the previous story about Mary DePo, these werewolves could only be killed by a silver bullet wrapped in sacred or blessed wax. When Billotte was a young boy, one such werewolf was killed along Gifford's Run. When he changed back to his human form, he was recognized as a man from Provence.

A rather sad tale emerged from the Lingle Valley on the border of Centre and Mifflin Counties around the same time Billotte was born. In 1838, a boy was born in a log cabin (where Edgar Allen Poe once spent the night) and soon developed some strange traits as he grew: long hairs grew between his fingers and on the sides of his feet. The boy's great-grandmother warned the family that the boy would be no good and that he would become a werewolf. Her prediction seemed accurate, because by the time he was eight, he had begun to run off at night, especially when the wolves were around. When the family would search for the boy in the morning, they often found him near the wolves' dens. Eventually, he ran off and could not be found. Shoemaker records that the family "uttered a silent prayer at his complete disappearance."

Researcher and author of *The Mystery Animals of Pennsylvania* Andrew Gable uncovered a similar story from York County. The Ross family took in a girl who had mysteriously appeared at the Warrington Meeting House and seemed to have no family. When the girl began to make wolf noises in her sleep, the family considered that she might be a werewolf. One night, she ran off, and when they tried to find her, they found only wolf tracks.

Though few details of the story have survived, a werewolf (or at least a malignant magical wolf often referred to as a spook wolf) allegedly once harassed the residents of Wolf Hollow in Blair County. A large white wolf preyed on their sheep, but rather than devouring them, it would only drink their blood. The terror was brought to an end by a man named Ben Burkett, who happened to be a hex doctor (a practitioner of folk magic). Tired of losing his sheep to the beast, he drew a "magical" circle in his barnyard where the wolf usually entered. The circle was probably part of a spell or incantation to bind the wolf to the spot so it could not run away. Such methods were used by practitioners of folk magic and were often employed against thieves. That night, when the wolf entered the circle, Burkett shot and killed the wolf with a silver bullet that he had moistened with his own saliva (which was most likely also part of magical ritual). The locals hailed him as a

hero when he marched through the street with the wolf's hide. Burkett's tale is another illustration of the link between magic and werewolves. However, in this case, magic was used to defeat the beast.

The story of the White Wolf of Sugar Valley, Clinton County, provides yet another example of the use of magic to defeat a werewolf/spook wolf. Though Shoemaker provided no date for the tale, researcher Andrew Gable has placed the tale around 1840. The monstrous white wolf was first encountered by a man named Philip Shreckengast, who watched it emerge from his barn with a bloodstained mouth. Shreckengast slammed his barn door shut quickly, catching the wolf's tail inside and severing it from his body. The wolf ran off, and a short time later, it was spotted by a preacher in the graveyard at what was then Brungard's Church, still yelping from its injury. Gable identified this site as St. Michael's Lutheran Evangelical Cemetery today.

The wolf must have continued to cause trouble, because the residents of Sugar Valley considered hiring a man named George Wilson to kill the white wolf. Wilson was widely known to have slain two werewolves in the past. A man named Jacob Rishel was on his way to contact Wilson when he encountered a local woman named "Granny" McGill, who was believed to be a witch. McGill offered Rishel another solution in the form of a hex. She told him to use a black lamb as bait for the wolf. It could not be just any black lamb, however: it had to be born under a new moon in the fall. Rishel was to put the lamb near Tunis Knob (or Cooper's Knob depending on the account) because the wolf lived nearby. Sure enough, Rishel and the residents of Sugar Valley were able to trap and kill the wolf using this method. Its head was mounted on a pole on Rishel's property. It was said that the jaw would still move, and the eyes would turn green, but all other wolves stayed away until it was removed.

Some "evil" wolves were said to cause problems for loggers in Elk Creek Gap, Centre County, in the late 1800s. At that time, during the height of the logging industry, cut trees were being transported out of the gap almost twenty-four hours a day. The trouble began when strange wolves descended from Hundsrick Mountain at night. Sometimes they would climb or jump onto the loaded sledges, and the horses would be unable to pull them. In some cases, the wolves would merely place their paws on the sledge, and it would become almost immobile, no matter how many horses pulled. It would take hours to get the sledges out of the gap. The wolves were unafraid of the workers and came back again and again. Many of the workers believed they were actually werewolves or witches in the form of wolves. Some of the

men resorted to placing hex signs and magical charms on their equipment, but it seemed to have no effect. Eventually, the workers tried to avoid hauling wood after sundown.

Though the preceding accounts, and others that we have not discussed here, all occurred in the 1800s or earlier, it would be incorrect to believe that reports of werewolves were absent in twentieth-century Pennsylvania. The werewolf has remained a popular monster in America and has not entirely disappeared from local legends. Though there are few who would admit to actually believing in werewolves, today such reports are often classified with Bigfoot sightings by those who conduct paranormal research.

Stories of a strange, werewolf-like creature have occasionally surfaced since the 1960s in the Shenango Valley in northwestern Pennsylvania. A "wolf boy" was allegedly seen around Sharon in the '60s. The following decade brought more werewolf sightings in the valley. A group of teenagers repeatedly saw what they thought was a strange bipedal, wolf-like beast on the banks of the river one summer, and other reports continued over the following years. As late as the 2000s, a strange man-like beast with dark fur was reported lurking in the woods behind a home near Hermitage. Some described the Shenango werewolf as being about four or five feet tall with black hair, a pig-like snout and knee and elbow joints that bend in the opposite direction of a human's. The creature has always been reported as being very fast.

During the 1980s and 1990s, a slightly different-looking creature was making its presence known around the same region. A seven-and-a-half-foot-tall werewolf covered in grayish-white hair was repeatedly spotted around the Hermitage area by a group of young men. They encountered the beast on trails in the woods and witnessed it crossing the road. Rumors had circulated that the beast was actually summoned by members of a Satanic cult that allegedly operated in an abandoned house in the woods. It was said to guard the area for the cult. Interestingly, when the old house was torn down, sightings of the beast came to an end.

Even more recently, a strange "dog man" was sighted in Westmoreland County along Route 66. A young man was driving to work when he spotted a strange figure lurking on the side of the road. When he came within about fifty yards of the figure, it darted across the road, moving more like an animal than a man. As it passed through the headlights, the man could see that the beast had a large upper body, no clothing and a dog-like snout. As the creature reached the other side of the road, it dropped to all fours and quickly dug under a chain-link fence and disappeared into the darkness. The

man reported his encounter to researcher Brian Seech of the Center for Unexplained Events.

Not long after the "dog man" incident, two unusual werewolf reports surfaced across the state near West Chester University. They were written by the people who experienced them and appeared in the magazine *Eerie PA* in 2006. One group of students who had been out drinking decided to finish off some six packs at Everhart Park. As they sat in the dark, a strange figure moved into the path in the distance. The figure seemed to watch them for about ten minutes, then disappeared back into the dark. The friends went back to drinking, but about a half hour later, they began to feel that they were being watched. Suddenly, a wolf-like creature leapt from the bushes. It allegedly walked upright like a man but was covered in hair and had the head of a wolf. The creature let out a growl, and the friends took off. They did not stop running until they were back in their dorms. The individuals involved were not sure if it was a prank or hoax, or if they had truly encountered something supernatural.

Another werewolf-like beast allegedly frightened a young woman near the campus about a year before. A student named Julia was waiting to be picked up by a friend near Farrell Stadium when she had the sensation that she was being watched. Thinking she would cross the street in case she was being followed, she looked over and stopped dead in her tracks. Staring at her was a wolf. A real wolf would be frightening enough, but this creature allegedly stood up on its hind legs like a human. Julia immediately ran as fast as she could and tried to hide. A moment later, her friend arrived, and she made a dash for her car. Jumping in, she told her friend to drive away as quickly as possible. It was her friend who wrote the account for the magazine, and she believed that Julia saw something unexplained, whether it was a werewolf or not.

Before leaving the subject of werewolves in Pennsylvania, I wanted to convey one last piece of information, just in case you are out for a long walk one moonlit night and see menacing shape stalking you in the distance. The storied hunter Daniel Kerstetter (1818–1898) passed along a method to stop a werewolf attack that had been passed to him by older members of his community. He said that if the werewolf gets close, use a dagger, sword, cane or something sharp to prick it between the eyes, on the ears or anywhere on the head where blood will quickly flow. Though it is not explicit, one might infer that this must be done before the werewolf draws blood. This will force the werewolf to return to his human form and end the attack. Kerstetter claimed that many lives had been saved over the years by following these instructions.

SOURCES

Ashley, Leonard R.N. *The Complete Book of Werewolves.* Fort Lee, NJ: Barricade Books, 2001.

Beresford, Matthew. *The White Devil: The Werewolf in European Culture.* London: Reaktion Books, 2013.

Bronner, Simon J. *Popularizing Pennsylvania: Henry W. Shoemaker and the Progressive Uses of Folklore and History.* University Park, PA: Penn State University Press, 1996.

Edwards, Kathryn A., ed. *Werewolves, Witches and Wandering Spirits: Traditional Belief and Folklore in Early Modern Europe.* Kirksville, MO: Truman State University Press, 2002.

Frost, Brian J. *The Essential Guide to Werewolf Literature.* Madison: University of Wisconsin Press, 2003.

Gable, Andrew. *The Mystery Animals of Pennsylvania.* Bideford, North Devon: CFZ Press, 2012.

Godfrey, Linda S. *Hunting the American Werewolf.* Madison, WI: Trails Books, 2006.

Guiley, Rosemary Ellen. *The Encyclopedia of Vampires, Werewolves, and Other Monsters.* New York: Checkmark Books, 2005.

Headings, Mark. Interview with author, March 2014.

O'Donnell, Eliot. *Werewolves.* London: Methuen, 1912.

Otten, Charlotte F., ed. *A Lycanthropy Reader: Werewolves in Western Culture.* Syracuse, NY: Syracuse University Press, 1986.

Shoemaker, Henry W. "Another Werewolf." *New York Folklore Quarterly* 7, no. 4 (Winter 1951).

———. "The Werewolf in Pennsylvania." *New York Folklore Quarterly* 7, no. 2 (Summer 1951).

———. "Werewolves in the Pennsylvania Wilds Once More." *Keystone Folklore Quarterly* 2, no. 1 (Spring 1957).

Sidky, H. *Witchcraft, Lycanthropy, Drugs and Disease: An Anthropological Study of the European Witch Hunts.* New York: Peter Lang, 1997.

Steiger, Brad. *The Werewolf Book: The Encyclopedia of Shape-Shifting Beings.* Detroit, MI: Visible Ink Press, 1999.

"Werewolf of West Chester." *Eerie PA* 1, no. 2 (Fall/Winter 2006–07.)

White, Thomas. *Witches of Pennsylvania: Occult History and Lore.* Charleston, SC: The History Press, 2013.

Wilson, Patty A. *Monsters of Pennsylvania: Mysterious Creatures of the Keystone State.* Mechanicsburg, PA: Stackpole Books, 2010.

————. *Totally Bizarre Pennsylvania.* Roaring Spring, PA: Piney Creek Press, 2008.

Woods, Barbara Allen. "The Devil in Dog Form." *Western Folklore* 13, no. 4 (October 1954).

THE SQUONK: A SMALL TALE FROM FRANKLIN COUNTY

Gerard O'Neil

The squonk is an enigmatic creature of apocryphal origin. From the hemlock-shrouded hills and hollows of central Pennsylvania, a curious tale has emerged of a creature impossible to capture. Lumberjacks were fond of tall tales, although this one concerns a small creature, albeit one that looms large in the imagination. The squonk is reputed to be the ugliest of creatures, and it laments its condition constantly. Consequently, it can be tracked by the trail of tears it leaves, especially on frosty nights, when it supposedly travels slower. However, when cornered or captured, the squonk deploys a unique defense mechanism. It cries itself into tears, leaving its would-be captor holding the bag—of water. The tale clearly falls into the category of *metamorphosis*, particularly the motif of shape-changing to avoid capture, with an unusual twist: it is usually pretty maidens—not ugly beasts—that are metamorphosed when cornered. The squonk is a good example of folklore that is "frozen" once recorded as literature, and yet it has taken on new dimensions in the realm of literature.

The tale of the squonk was included in William T. Cox's *Fearsome Creatures of the Lumberwoods* in 1910. There is no record of the story being told in Pennsylvania, and this may be a misattribution. Alternately, it is possible that after extensive logging of the hemlock forests in Pennsylvania, the squonk was extinct there, due to habitat destruction. Meanwhile, the logging camps moved west to the Great Lakes Region and beyond. In this sense, the story contains an element of community memory. The tale gained new

Coert Du Bois' depiction of the elusive squonk from *Fearsome Creatures of the Lumberwoods.* *Courtesy of Sawyer Library, Williams College.*

life, however, when George Luis Borges included Cox's short word-for-word account in his 1969 *The Book of Imaginary Beings*:

THE SQUONK
(Lacrimacorpusdissolvens.)

The range of the squonk is very limited. Few people outside of Pennsylvania have ever heard of the quaint beast, which is said to be fairly common in the hemlock forests of that State. The squonk is of a very retiring disposition, generally traveling about at twilight and dusk. Because of its misfitting skin, which is covered with warts and moles, it is always unhappy; in fact it is said, by people who are best able to judge, to be the most morbid of beast. Hunters who are good at tracking are able to follow a squonk by its tear-stained trail, for the animal weeps constantly. When cornered and escape seems impossible, or when surprised and frightened, it may even dissolve itself in tears. Squonk hunters are most successful on frosty moonlight

*nights, when tears are shed slowly and the animal dislikes moving about;
it may then be heard weeping under the boughs of dark hemlock trees. Mr.
J.P. Wentling, formerly of Pennsylvania, but now at St. Anthony Park,
Minnesota, had a disappointing experience with a squonk near Mont Alto.
He made a clever capture by mimicking the squonk and inducing it to hop
into a sack, in which he was carrying it home, when suddenly the burden
lightened and the weeping ceased. Wentling unslung the sack and looked in.
There was nothing but tears and bubbles.*

The (supposedly authoritative and scientific) name of the squonk,
Lacrimacorpusdissolvens, is derived from the Latin words for "tear," "body"
and "dissolve." Borges, of course, problematizes the notion of things
imaginary: while limiting his book to "the strange creatures conceived
through time and space by the human imagination," he notes that his title
justifies the inclusion "of the point, of the line…of all generic terms, and
perhaps each one of us."

This account can be read as a cautionary tale or warning against
melancholy disposition. However, this story was told to hard-working and
hard-drinking lumberjacks, not children, and is more likely the product of
delirium tremens than any pedantic impulse. Perhaps it served as a cautionary
tale to ugly lumberjacks.

The motive for squonk-hunting is also unclear. If, as outsider poet Thomas
L. Vaultonburg has suggested, the tears are valued by alchemists, then
perhaps the squonk was readily hunted into extinction, but the lore makes
no mention of using a waterproof sack for this purpose. Other dubious
sources have suggested that the skin was the hunter's objective. For obvious
reasons, squonk skins will never be found in any museum of cryptozoology.

The experience of the squonk hunter bears a curious resemblance to
one variant of the "snipe hunt," which is a practical joke or "fool's errand"
that involves experienced outdoorsmen making fun of newcomers by giving
them an impossible or imaginary task. Inexperienced campers or hunters
are told about a small yet dangerous creature called the snipe and are given a
ridiculous method for catching it - such as running around the woods carrying
a bag and making strange noises. The "optimal" snipe habitat is usually on a
trail remote from the camp, and those who are in on the joke return to camp
and have a laugh at the newcomer's expense. However, in another variant of
snipe hunting, a large group spreads out to hunt the snipe with sacks. After
thrashing about the woods in the dark for some time, the snipe is captured

by one of the leaders of the hunt and with much care and fanfare is brought back to camp. When the bag is opened, the "snipe" escapes so quickly that no one sees it. In this sense, the squonk joins a legion of imaginary creatures invented to scare or confuse newcomers, such as the Australian "drop bear," the American "jackalope" and Scotland's "wild haggis."

Recently, the squonk has undergone a shift in legend ecology to popular music, including progressive rock and even rap music. Most of these instances are simply passing lyrical references, and the fullest treatment to date is that of the rock band Genesis; "Squonk" is one of the heavier songs on their 1976 album *A Trick of the Tail*. However, after the lyrics, Genesis adds the provocative question: "True or False?" The implication is that an apparently absurd tale can convey insights into a human condition—insights that are psychologically true in the sense that they are relevant to the lived experience of the listener.

SOURCES

Borges, Jorge Luis. *The Book of Imaginary Beings.* London: Random House, 1970.

Cox, William T. *Fearsome Creatures of the Lumberwoods, With a Few Desert and Mountain Beasts.* Illustrated by Coert Du Bois, with Latin Classifications by George B. Sudworth. Washington, D.C.: Judd & Detweiler, Inc., 1910.

RED MENACE? THE APE-BOY OF THE CHESTER SWAMPS

Edward White

Outside of Philadelphia in Delaware County lies a busy strip of waterfront along the Delaware River near Chester, Pennsylvania. This area is home to the Philadelphia Airport, a soccer stadium, a casino, standard-bred harness racing and several industrial complexes. In stark contrast to the concrete jungle that the area is today, it was once a vast swamp. Some of the original swamp is still preserved in the John Heinz National Wildlife Refuge at Tinicum. This area was, and still is, home of the legend of the Ape-Boy of the Chester Swamps.

The legend appears to have started in the mid-1700s and concerns a hideously unattractive, lanky, redheaded boy who was savagely teased by his peers. After the boy had tolerated years of abuse, he finally had enough and ran off into the swamp never to be seen again—at least as a human boy. When he went into the swamps, the boy gradually became more animal-like and grew reddish hair all over his body. He also seemed to have an unnaturally long life, though there is no clear explanation as to why that would be. From the Revolutionary War to present day, the creature has been spotted roaming the swamps foraging for food. Researcher and author Andrew Gable chronicled several reports from the early twentieth century of ape-like creatures from former swamplands. Some of those sightings were thought to be hoaxes or merely urban legends, while others were more mysterious. Sightings continue to occasionally be reported today by visitors to the wildlife preserve. One commonality among the various accounts of the Ape-Boy is that he is harmless to people and retreats into the swamp when discovered.

The John Heinz wildlife preserve at the Tinicum Watershed encompasses the remains of the Chester Swamps. The Ape-Boy has reportedly roamed this area for more than 250 years. *Courtesy of Edward White.*

Occasional sightings of the red-haired Ape-Boy at the Tinicum Watershed continue to this day. *Courtesy of Edward White.*

Gable also noted that there seemed to be some similarities between the legend of the Ape-Boy and two other legends that emerged around the same time in generally the same geographic area. One of those legends was that of the infamous Jersey Devil, who was born a demon-like child to the Leeds family of New Jersey in the 1700s. Just after the monster's birth, it flew off to live in the Pine Barrens and has reportedly been lurking there ever since. Over the years, the Jersey Devil has also been sighted in eastern Pennsylvania, near Philadelphia. Like the Ape-Boy, the Jersey Devil fled to the fringe of civilization and has lived for more than two centuries.

The other legend originated near Brandywine Creek near the Delaware and Pennsylvania border during the American Revolution. It involved a red-haired Continental soldier of French descent named Gil Trudeau. Trudeau's fellow soldiers noticed that he would disappear from camp during a full moon and sometimes return disheveled and with bloodstains on his clothing. They suspected that he was a werewolf but soon discovered that they were not entirely correct. One of the soldiers shot a strange red-haired fox-like creature one evening under the full moon. When he tracked it, he discovered that it had turned back into Trudeau, who subsequently died. His were-fox ghost is said to haunt the area and is referred to as Red Dog Fox. He was another red-haired man-beast.

So why does such a tale of a harmless yet bizarre creature like the Ape-Boy become part of local folklore? For many early colonists who were already living on the edge of "civilization," there was perhaps nothing as disturbing as the idea of disappearing into the wilderness and becoming "savage." It could be equated with the concept of "going native" and leaving European settlements to live in the wilds with the Native Americans, who were often viewed as savages in their minds. In that way, the legend might reflect the environmental and cultural fears of the early Pennsylvanians.

Another possible explanation is tied to the Revolutionary War, a time when sightings were allegedly common. Maybe a link was made between the monstrous red-haired man-beast and the British Redcoats, implying that they were monsters as well. Maybe the story had a more utilitarian purpose. It might have been used as a simple scare tactic to keep children from wandering off into the swamplands. Or was this the first anti-bullying message? It has even been suggested that somehow, a small population of red-haired apes ended up in the swamp and has survived for decades in the midst of the surrounding urban environment. Most likely, we will never

know the true facts behind the legend. One thing is certain, however: if visiting the wildlife preserve, you should probably fear Lyme disease more than the red-haired Ape-Boy.

SOURCES

Gable, Andrew. *The Mystery Animals of Pennsylvania.* Bideford, North Devon: CFZ Press, 2012.

Lake, Matt. *Weird Pennsylvania.* New York: Sterling Publishing Company, Inc., 2005.

"The Legend of the Ape Boy." *Pennsylvania Haunts and History.* http://hauntsandhistory.blogspot.com/2010/05/legend-of-ape-boy.html.

Wilson, Patty A. *Monsters of Pennsylvania.* Mechanicsburg, PA: Stackpole Books, 2010.

UFOS INVADE THE POCONOS

Tony Lavorgne

For decades, the Poconos and the surrounding area have attracted visitors and guests who wish to enjoy the beautiful mountains and recreational opportunities. Some of those visitors may have come from very far away. Since the 1950s, there have been sporadic UFO sightings by local residents and visitors. Many of these witnesses have been very credible and have had little reason to risk ridicule by fabricating such claims. What, then, have they been seeing?

Ever since Kenneth Arnold spotted the first "modern" UFOs, or flying saucers as they were called, near Mount Rainier in 1947, the American public has been fascinated by the idea of visitors from space. In the post–World War II years, more Americans watched (and traveled in) the skies than ever before as new jet and aircraft technology developed. The onset of the Cold War brought with it the very real fear of death from above through nuclear annihilation. Against such a backdrop, the modern UFO phenomena emerged. Though UFO only means unidentified flying object, it quickly became associated with the idea that aliens from outer space were at the controls. For some people, the idea of aliens with technology more advanced and possibly more destructive than our own was unnerving. Government denial of the UFO phenomenon could cause a feeling of helplessness as individuals sought to explain the things that they witnessed. Much like the threat of nuclear destruction, there was no protection from the possible technological monsters in the sky.

The Poconos seemed to be a hotbed of UFO sightings in the middle of the twentieth century and provide good examples of the phenomena in

this state. Beginning in the 1950s, at the height of the original UFO craze, a number of strange shapes and lights were spotted in the sky. The first recorded incident occurred on February 23, 1954, when some people from the Snow Hill area saw what was described as a "ball of fire" drop from the sky. The witnesses, who could see the object at a distance, believed that the object burned on the ground for about twenty minutes. Considering the possibility that an aircraft may have gone down, state police aided locals as they searched the woods where the object appeared to have crashed. Nothing was ever found.

Another sighting occurred that same year on July 6. Two men near Tannersville watched a UFO fly low near the top of Big Pocono and then fly toward Mount Pocono. One of the witnesses claimed the object was a large "shiny-white" box. A few years later, in September 1957, an object described as a flying saucer with a sphere-shaped tail was observed moving north across the Delaware Water Gap. One sighting that was quickly explained occurred in August 1959. Four children reported seeing "ghosts" flying around in the sky over Mount Pocono. When their mother looked at the lights, she thought that they looked vaguely saucer-shaped. Within a few days, it was discovered that the children had actually seen spotlights from a Tannersville carnival that were reflecting off the low clouds. A UFO spotted on April 4, 1965, also likely had a scientific explanation. Several residents of Marshall's Creek witnessed a bright light with a tail head downward across the sky before disappearing. From their description, it seems likely that the individuals saw a meteor burning up in the atmosphere.

The strangest of the UFO encounters occurred on March 1, 1973, at nearby Saylors Lake. That evening, over a dozen witnesses, including a state trooper, watched waves of strange lights pass over the lake in fifteen-minute intervals. The witnesses counted between thirty-nine and forty-two objects in total between 7:25 p.m. and 10:45 p.m. According to Mrs. Howard Pfeiffer, the lights would come into view slowly from the west and pick up speed as they passed over the lake. The lights remained visible for about three minutes, and Mrs. Howard described them as being about the size of a "child's wading pool." Some of the lights were white in color, while others were reportedly blue and red. Some of the witnesses called the police, and Pennsylvania state trooper Jeffery Hontz arrived on the scene to investigate. He personally saw four of the lights and estimated that they were flying at about 1,500 feet. Hontz, when asked about one of the lights, said, "It was like a Christmas tree flying in the air." Trooper Hontz and the other witnesses all noted that the objects were not making any noise, unlike an airplane.

In the days that followed the lengthy sighting, no satisfactory explanation was discovered for the strange lights. A reporter from the *Allentown Morning Call* did some investigating and found that the Allentown-Bethlehem-Easton Airport (Lehigh Valley International) was not equipped with surveillance radar, so it was unable to detect the strange objects. The New York Traffic Control Center, which was responsible for monitoring East Coast flights, informed the reporter that aircraft at 1,500 feet or less would be difficult or impossible to detect. The reporter then turned to the air force for a possible explanation. Public information officer Major Larry Brown denied that there were any military operations in the area that night.

Before the incident even had a chance to fade into memory, the strange lights made a brief encore appearance. On March 13, residents of Saylors Lake saw lights in the sky again. Around 7:15 p.m., a dozen glowing disks crossed over the lake as before, eventually disappearing into the eastern sky.

Since the Saylors Lake incident, there have continued to be sporadic reports of UFOs in the region of the Poconos, though most of these incidents have had a practical explanation. For example, the descriptions of two fireballs spotted on different nights in early March 1991 seem to indicate that they were, in fact, meteors. In 1986, a hot air balloon triggered numerous UFO reports in Monroe County because it was misidentified. Still, several of the earlier accounts remain unexplained, especially the lights above Saylors Lake.

Flying Christmas trees, shining boxes and lights with no sound—can Cold War anxiety and the popular obsession with flying saucers alone explain these incidents? Those who saw the Saylors Lake phenomenon said that they did not feel threatened at all. Could it have been some type of misidentified natural phenomena or perhaps a secret government project? Since there was no video footage or other clues, it is unlikely that the answer will ever be found. Many of the witnesses were clearly willing to believe that they saw something strange—perhaps even paranormal. Ultimately, what people are willing to believe may be more important than what actually took place. With hundreds of UFO reports from around Pennsylvania and thousands from around the country in the decades since World War II, it is clear that the belief in UFOs and the associated belief in aliens has been permanently engrained in modern folklore. UFOs ultimately represent the unknown potential or horror of technology, something that Cold War America was all too familiar with.

SOURCES

"42 UFOs Spotted Over Lake." *UFO Investigator*, April 1973.

McNaughton, Adam. "UFO Sightings Not Alien to the Poconos." *Pocono Record*, January 19, 2008.

Seibold, David J., and Charles J. Adams III. *Pocono Ghosts, Legends and Lore.* Reading, PA: Exeter House Books, 1991.

"UFOs and Others in Poconos." *Pocono Record*, October 22, 2013.

Wilson, Patty. *UFOs in Pennsylvania: Encounters with Extraterrestrials in the Keystone State.* Mechanicsburg, PA: Stackpole Books, 2011.

PART III

MIRACLES AND MAGIC

HELP FROM BEYOND

Since Pennsylvania's earliest days when William Penn made it a haven for those of different faiths, Quakers, German Pietist sects, mainline Protestants, Catholics, Orthodox Christians, Jews and many others have called the state home. The supernatural is a key part of religious experience, especially when it comes to folk religion. Folk religion can be difficult to define, but most scholars would agree that it is distinct from the mainline doctrinal beliefs of organized religions. That is not to say that those who practice folk religion are not members of these mainline religions but that they are incorporating additional beliefs, rituals and practices that are not a part of the official doctrine. In many ways, this is a creative process among the practitioners, adding traditional beliefs, local customs and frequently elements of folk healing, folk magic and superstition. It is religion as it is lived. It is the religion of everyday life.

Though sometimes viewed as a corruption of "true" religious practices, folk religion often serves as a way for people to interact more directly with their faith. Folk religion is also a very sensory experience. It takes theological and supernatural ideas and makes them real and tangible, and it welcomes direct supernatural action in the world. Also, especially in regard to folk

healing and folk magic, it provides a means to supernaturally manipulate the environment, providing hope and the possibility of influencing outcomes with direct help from God. Whether it be "unofficial" miracles, letters directly from heaven, prophetic dreams or Pennsylvania Dutch folk healing and witchcraft, all of the essays in this section reflect the belief that there is some greater force at work in the world.

MINING MIRACLES

Katherine Barbera

In 1903, the *Pittsburgh Press* ran a story titled "Strange Coal Formations, Peculiar Pictures in the Anthracite Product." According to the stumped reporter, in anthracite coal veins in Pennsylvania, miners were finding illustrations in the earth. They found drawings of birds, snakes, flowers and even more surreal forms like angels and devilish creatures. In one shaft, there was a large depiction of a church; in another, there were ox-eyed daisies. The pictures were found all over Pennsylvania's anthracite region but only in its "oldest mines." The workers could not make sense of them. They were "strange" indeed.

Over time, these images joined the Pennsylvania mining community's already cavernous body of folk tales, beliefs and superstitions. The images became omens of good luck if honored with a prayer or even just left alone. If they were defaced or destroyed, it meant a cave-in or other major disaster loomed on the horizon. The *Pittsburgh Press* reported one instance in Plymouth, Pennsylvania, in which several miners tossed coal at an image of a flock of sheep, destroying it. Just a few hours later, there was an explosion, and nearly one hundred men died.

Strange occurrences like the anthracite illustrations are relatively common in Pennsylvania because of the state's rich mining history. With bituminous, or soft coal, deposits in the west and anthracite, or hard coal, veins in the east, Pennsylvania's coal production was essential to the U.S. industrial economy in the nineteenth and early twentieth centuries.

Of the stories that came out of this period, many involved accidents and tragedies. In fact, danger is a nearly ubiquitous theme, but sadly, this should

come as no surprise. Coal mining was (and is) notoriously risky. Fatalities were common, gas explosions were widespread and cave-ins were frequent. Between 1901 and 1925 alone, there were more than three hundred coal mining accidents that killed five or more people. In 1907, the worst coal mining year in U.S. history, more than three thousand people died. Coal miners faced immediate danger every day, and they waged war against long-term effects to their health and their environment. Needless to say, the industry took its toll on the people and the land in the Keystone State.

But in some ways, it is this harsh reality that created the miners' storied environments. Mines were murky, dark, dangerous and unpredictable. For the men who braved the depths of the earth, the difference between life and death was based on luck. Folk beliefs helped miners justify their daily experiences, and through the stories, the miners coped with the risk. Blurring the lines between superstition, theology and myth, these stories pervade mining communities in Pennsylvania.

One of the most well-known mining miracles occurred in Scranton, Pennsylvania. In 1912, the *Reading Eagle* reported that a $500,000 monastery in West Scranton would not be deserted because engineers had, much to everyone's surprise, pronounced it safe. Although this was welcome news for the city's Catholic community, the story came too soon. Unbeknownst to the article's author, a series of uncanny events was about to take place at the monastery.

A group of Catholic Passionist priests constructed the monastery in the first few years of the twentieth century. It is located in an area of Scranton known as the Round Woods, and it rests high above the city, overlooking the region. Scranton is in the heart of Pennsylvania coal country, and like many of the other cities and towns in the area, it sits atop a network of old mine shafts. Fittingly, the Passionists named the monastery after Saint Ann, the mother of Mary and a patron saint of miners.

In Pennsylvania, many of the mining immigrants were Catholic or Orthodox. Among immigrants, saints were often looked to for protection from harm. Miners wore or pocketed relics or medals to protect themselves against the danger of their work. Over time, certain saints became associated with miners, and one of the most common was Saint Ann.

There is no clear explanation as to why Catholic and Orthodox Christians associate Ann—also known as Anne or Hanna—with miners, but there are several interpretations in circulation. According to most Catholics, Saint Ann is the patron saint of miners because the Church often uses precious jewels or metals to illustrate the Holy Family. Ann is not part of the immediate Holy Family, but she carried Mary, a precious jewel, in her womb. Another

unrelated explanation originated in France, where devotion to Saint Ann was widespread in the middle ages. According to the Catholic Passionist congregation, Saint Auspice entombed Saint Ann's body in a cave, where it remained until it was discovered centuries later by a group of miners.

Regardless of her liturgical or historical connections, the Passionists aptly named the monastery in Saint Ann's honor. The Passionist congregation held their first mass in the monastery's chapel in 1904, and for the first few years, they experienced relatively few problems. The city was receptive to their presence, and their congregation was growing. But in 1911, their situation changed. That year, the earth underneath the monastery shifted. Subsidence in the mine caused the ground to shake and the building to crack. The damage was so bad that the Passionists were forced to evacuate. For some time, the congregation waited for the building to collapse, but mysteriously, the structure remained standing. By 1912, as the *Reading Eagle* reported, inspectors told the priests that it was safe to return.

Slowly, the Passionists began to make repairs, and all seemed well until 1913 when the land gave way again, this time even more severely. Ultimately, the subsidence threatened to drag the monastery down the hill into the city. Engineers all but condemned the building. Again, the congregation waited anxiously for the final collapse, but it never came. In fact, the subsiding earth stopped and, miraculously, reversed direction. The inspectors were baffled. After an investigation, engineers found that two large boulders had settled underneath the monastery, stabilizing the building.

Soon after these uncanny events, the Catholic community in Scranton renewed their devotion to Saint Ann. Every year on her feast day, they hold a massive Novena in her honor. It is a large devotion, drawing hundreds of visitors over the course of nine days. In 1928, the *Reading Eagle* reported that over 25,000 people attended mass on Saint Ann's feast day. Since then, the number has only grown. In 1997, over 100,000 pilgrims flocked to Saint Ann's for the Novena.

Although many mining folktales involve danger, many also include themes of escape. In these accounts, men are helped or led to freedom by miraculous means. Among Orthodox Christians in southwestern Pennsylvania, one of the best-known examples is the Darr Mine Disaster. It is most commonly known as one of the worst coal mining accidents in U.S. history, but for many Orthodox Christians, it a story of faith and hope.

On December 19, 1907, just before noon, a massive explosion shook Jacob's Creek and the surrounding area. For the families who lived in the small mining communities near the creek, it was not difficult to guess the

The December 20, 1907 headline from the *Pittsburg Dispatch* announcing the disaster at the Darr Mine. *Courtesy of the Carnegie Library of Pittsburgh.*

The *Pittsburg Dispatch* continued to print detailed stories of the Darr Mine disaster and subsequent rescue attempts in the days and weeks that followed. *Courtesy of the Carnegie Library of Pittsburgh.*

source—it came from the Darr Mine. There had been a terrible methane gas explosion.

The rescue effort began almost immediately, but the scene was horrific. There were almost no survivors, and many of the bodies were unidentifiable. According to the official report from the Pennsylvania Department of Mines on the accident, of the 240 men who entered the mine that day, only 1 man survived the explosion; 239 men died in the blast. Later, department officials determined that the open-flame lamps carried by the workers ignited gas and dust in the mine, causing the explosion. The community was devastated, but as they rallied for the recovery effort, they made a remarkable discovery: dozens of mine employees had not shown up to work that day.

Like other mines in Pennsylvania, most of the workers at the Darr Mine were immigrants. Many were Hungarian and Italian, but there was also a large population of Carpatho-Rusyn immigrants in the area. Much to the surprise of those in the rescue effort, nearly all of the Carpatho-Rusyn workers had stayed home for the Feast of Saint Nicholas of Myra. The feast, held on December 19, according to the Julian calendar, is an important holy day in the Rusyn Orthodox Church. In this miraculous coincidence, dozens of men escaped the deadly accident at the Darr Mine.

For believers, the Darr Mine Disaster affirmed their devotion to Saint Nicholas, but the accident also had other consequences. Because of the disaster, the Pittsburgh Coal Company—the owner of the Darr Mine—banned the use of open-flame lamps. Also, a few years later in 1910, the U.S. government created the U.S. Bureau of Mines, which was responsible for researching new safety methods and monitoring accidents throughout the country. The Darr Mine Disaster and the other horrific accidents that occurred in 1907 brought the dangers of mining to the attention of the public.

Until the turn of the century, conditions in the coal mines were largely unknown to people outside the communities that revolved around them, but that does not mean outsiders were not curious. For the public, there was a certain mystique surrounding them. In 1930, a reporter for the *Reading Eagle* said his visit to a Pennsylvania coal mine was "bewildering." He was surprised by the cool temperature, the underground mule stable, the winding tunnels and the pump boy sitting in the dark with his bright blue eyes and coal-covered face. To outsiders, coal mines were captivating but chilling "underworlds." Interestingly, as the public paid more attention to coal mining accidents, they also heard news of other aspects of coal mining life, including folk religion and beliefs. By the first decades of the twentieth

century, articles on coal mining were common in newspapers throughout Pennsylvania and the nation.

Of these newspaper accounts, few captured the nation's attention more than mine rescues. One of the best examples is the Sheppton Mine accident. Although many mine rescues occurred before the second half of the twentieth century, this one occurred within the reach of modern memory. For two weeks in August 1963, a small town in central Pennsylvania captured the attention of the entire nation. Headlines tracked the progress of rescue teams as they struggled to reach three men trapped deep in the Sheppton Mine near Hazelton, Pennsylvania. The accident was a well-documented event, and the technology developed in the Sheppton rescue effort has been recognized in other more recent cases, notably in Somerset County, Pennsylvania, and near Copiapo in Chile. Less documented are the experiences of the men trapped in the Sheppton Mine. Like the illustrations in the anthracite mines, the subsidence at Saint Ann's and the accident at the Darr Mine, the Hazelton Mine rescue blends ideas of labor with folk religion and superstition.

The accident at Sheppton Mine occurred on Tuesday, August 13, 1963, just before 9:00 a.m. David Fellin, a co-owner of the mine, and two other men were working between three hundred and four hundred feet below the surface when a traveling mine cart slammed into a wooden support beam. For the notoriously "over-mined" site, the impact was disastrous. It loosened the brace and caused a massive landslide. The three miners working that day—David Fellin, Louis Bova and Henry Throne—were trapped inside.

There was no chance of escape for the men because the accident smothered the mine's only exit in rubble. According to most of the contemporary newspaper accounts, as the debris fell, Fellin and Throne jumped to one side of the shaft while Bova jumped to the other. Later in 1977, however, Fellin told the *Observer-Reporter* that Throne and Bova had been working in two separate areas. Fellin, as their boss, was walking between them directing their work. Either way, the massive landslide separated Bova from Fellin and Throne. Sadly, we do not know Bova's side of the story. Although rescuers worked for weeks to find him, he was never recovered, and his body was never found.

After the initial cave-in, Fellin and Throne were trapped in a space approximately six feet long by five feet wide by three feet high. They could not stand, and they had minimal supplies. According to Fellin, they had two miners' lamps, a little water in a jug, a broken hatchet, a crowbar, an old saw and a rasp. In another account, he leaves out the lamps but adds electrical

tape, a cable, rags and a piece of pipe. Using these tools, the men were able to dig a well to brackish water.

Conditions in the small cavern were severe. It was nearly freezing, and the men were wearing only cotton shirts, overalls and work boots. To keep warm, they huddled together. Throne sat between Fellin's legs while Fellin breathed warm air down his neck and rocked them back and forth. They would switch every hour. In 1977, Fellin told the *St. Petersburg Times* that this method was Throne's idea. He had a military background and knew how to keep warm.

They had dirty water to drink but no food to eat. When hungry, they ate coal, dust or bark. After several days with no sign of rescue, the two men decided to dig their way out. Using their hands and the hatchet, they dug thirty-five to forty feet through the debris. Fellin estimated that it took them a day and a half. At no point during the entire ordeal could they stand. They could only sit or crawl.

Meanwhile, on the surface, a rescue effort was underway. It had begun almost immediately after the accident. The team included officers from the United Mine Workers of America, officials from the national Bureau of Mines, local miners and volunteers. Gordon Smith, the deputy state secretary of mines, was in charge of the operation. At first, the team tried tunneling through the original shaft, but because of gases from the mine and the risk of further collapse, they abandoned this method. On Friday of the first week, there was another major landslide, and Smith made the decision to drill from the surface instead.

Smith consulted with local miners familiar with the area, including Fellin's brother Joe, and together they mapped out a spot to start drilling. Remarkably, after many hours of deliberation and planning, they reached the miners below. Shockingly, they found Fellin and Throne on their first attempt. Through a six-inch hole, Fellin and Throne saw their first light in nearly a week.

At this point, the tragedy became a nationwide news sensation. Hundreds of reporters and spectators flocked to the site to watch the rescue effort. The crowds were so massive that one spectator was actually injured.

On Sunday, August 26, the rescue team began drilling another hole six inches wide and parallel to the first one. It took them more than twenty hours to drill it. This hole would have been their escape route, but the team missed the mark. The rescuers attempted three times to dig an escape shaft before they were successful. The final hole emerged right between Fellin and Throne as they lay in the small tunnel below. They enlarged the hole

to eighteen inches before the team finally lifted the two men to the surface. Through the entire process, Fellin directed the team's progress from below using a radio.

Almost immediately, Fellin and Throne were rushed to the hospital. Throne was treated for an injured hand, but astonishingly, both men were in relatively good health. Fellin did ask his doctors for a mental evaluation. He said he had seen and experienced things he could not explain.

While they were underground, both Fellin and Throne had visions. Some were religious, and others were more occult, but both claimed that without their mysterious visitors, they would not have escaped. According to Fellin, in the first twenty-four hours, Pope John XXIII appeared to them. This was just six months after the Pope had passed away. Fellin also said that he stayed with them through most of the ordeal. Coincidentally, on August 21, the rescue party lowered several relics to the trapped men. They included a rosary and several Saint Christopher's medals. The articles were donated by a Hazelton family who brought them back from Rome. The relics had been blessed by the Pope John XXIII.

Fellin also claimed that several men with lights appeared to them. They rode into the cave on a chariot with no horse. They wore utility belts and miners' helmets with battery packs, and they reeled wire from a spool. Fellin recalled that this was the only time he was afraid during the entire ordeal, even during the initial accident. Against Fellin's judgment, Throne asked them to bring light into the cavern. The men soon disappeared, but a bluish light filled the cavern. It was by this light that Fellin and Throne were able to dig thirty-five to forty feet toward the surface.

By the same blue light, Fellin and Throne saw a white marble staircase leading upward toward the roof of the small cavern. At the bottom of the stairs, there was a door and two men standing guard. At one point, Throne tried to break down the doors, but the stairs disappeared and he hit the cavern wall, hurting his hand.

Back on the surface, after the rescue team freed Fellin and Throne, the effort to find Bova continued, even after hope of finding him alive was lost. Tragically, on September 6, the Sheppton Mine collapsed again and the furious recovery effort for Bova was halted. Too many of the supports had collapsed. Later, the community placed a grave and memorial for Bova on the surface above the mine.

Illustrating the depth of miners' ingenuity and perseverance, the stories told the American public about the dangers of mining, the persistence of hope and the struggle against an "underworld" frontier. The Sheppton Mine

rescue, and other stories in mining folklore, exist in the intersection of labor, religion and myth. They contain elements from different areas of miners' lives. Without ignoring the differences between miners' religions and cultures, it is clear that they lived life on a two-way street. Their hazardous working environments influenced their belief systems, but their belief systems also influenced how they perceived their environments.

Despite the harsh realities of life beneath the earth, strange and mysterious stories of hope appear in communities and newspapers throughout Pennsylvania. They tell us about a more hopeful history of Pennsylvania's coal mining industry. In some ways, through these stories, the miner became a paradigm of American identity. Rich in ethnicity and heritage, the tales span regions and religions. From Scranton to Jacob's Creek to Hazelton, these mining miracles provide windows into worlds of strength and perseverance.

SOURCES

Apichella, Michael. "Commentary: The Days All Eyes Focused on Sheppton." *Standard Speaker,* August 13, 2013.

Beaver County (PA) Times. "Body Seen in Mine." August 30, 1963.

———. "Mrs. Bova in Hospital." August 27, 1963.

———. "3 Trapped Miners Located." August 19, 1963.

Butler, George. "Trapped Miners See Staircase to Heaven." *Gadsden Times,* December 17, 1978.

"Darr Mine Disaster." In *Report of the Department of Mines of Pennsylvania.* Pennsylvania Department of Mines and Mineral Industries, 1908.

Dubruiel, Michael. *Mention Your Request Here: The Church's Most Powerful Novenas.* Huntington, IN: Our Sunday Visitor Publishing, 2000.

"Explosion at Darr MinePa." *Coal and Coal Trade Journal* 46 (1907).

Gettysburg (PA) Times. "Lower Religious Relics to Miners." August 21, 1963.

———. "One Trapped Miner Had Premonition of Danger." August 21, 1963.

———. "Spectator Hurt at Rescue Site." August 27, 1963.

———. "Two Trapped Men Honored at Club Fete." September 18, 1963.

Jackson, Kent. "Sheppton Rescue Technique Saved Lives Decades Later." *Standard Speaker,* August 15, 2013.

Milwaukee Sentinel. "Hazelton Mine Slope Collapses." September 7, 1963.

Morning Call. "Mine Disaster Was 25 Years Ago Sheppton Cave-in Claimed One Life." August 25, 1988.

Morning Record. "Hope Lost of Finding Bova Alive." September 3, 1963.

Observer-Reporter. "Old-Timer Recalls Underground Ordeal." March 8, 1977.

Oscala Star-Banner. "Hope Flickers for Moment then Fades for Lou Bova." August 29, 1963.

Pittsburgh Post-Gazette. "Fellin Touts Mine Site, Rues Missing Bova." September 5, 1963.

———. "Mine Rescue Figure Lost." March 10, 1966.

———. "Miner Fellin Subpoenaed." September 19, 1963.

———. "Small Mines Excluded in Safety Bill: Bill Won't Cover Firms Employing Fewer than 15 Men." August 20, 1964.

Raphael, Michael. "Tens of Thousands Flock to Novena at St. Ann's." *The Hour,* July 23, 1997.

Reading Eagle. "Chronology of Events from Mine Cave-in to Rescue." August 27, 1963.

———. "Mine Probe Plea Taken to Court: State Asks Study in Search for Bova." September 9, 1963.

———. "New Shrine of St. Ann at Scranton to Be Opened Soon." January 28, 1928.

———. "Scranton Monastery Safe." March 18, 1912.

———. "Sheppton Mine Vigil Finally Abandoned." November 16, 1963.

———. "Solons Back in Session." February 17, 1964.

———. "Throng Attends Catholic Ceremonies at Scranton." July 27, 1954.

———. "Today Marks Anniversary of Rescue and Tragedy." August 27, 1964.

———. "Troop C Men Sent to Sheppton." August 26, 1963.

———. "US Bureau Reviews Sheppton Mine Rescue." October 29, 1963.

Saskatoon Star-Phoenix. "Trapped Miners Get Soup, Cigar." August 19, 1963.

Scranton (PA) Tribune. "Charter Asked For." October 1, 1902.

———. "Monastery for Paulists." April 18, 1901.

———. "Monastery for the Passionist Fathers." September 15, 1902.

———. "Negotiating for Land." December 12, 1901.

———. "To Build Monastery Here." May 6, 1901.

———. "To Locate at Harvey's Lake." May 20, 1902.

Star News. "Volunteer Risks Life in Pa Mine." August 31, 1963.

St. Petersburg Times. "Buried Alive for 15 Days: An Ex-Coal Miner Remembers," March 7, 1977.

Toledo Blade. "David Fellin and Henry Throne." May 24, 1964.

Walters, Fred. "Stronger State Laws Are Needed to Avert Small Mine Disasters in Penna." *Gettysburg Times,* October 3, 1963.

Wilmington (DE) Sunday Morning Star. "St. Ann's Novena to Begin Tomorrow." July 17, 1968.

Yuhaus, Cassian J. *Speaking of Miracles: The Faith Experience at the Basilica of the National Shrine of Saint Ann in Scranton, Pennsylvania.* Mahawah, NJ: Paulist Press, 2006.

THE LOST CHILDREN OF THE ALLEGHENIES

Michelle Bertoni

This strange story took place in the Allegheny Mountains of Pennsylvania, during a late April snowfall in 1856. The Cox family lived in the forests of Spruce Hollow, where Samuel Cox provided for them by hunting. His wife, Susannah, took care of the house and her three lovely children. The family seemed content with their life in the mountains—until things took a terrible turn one April morning.

The Cox family was sitting down to a delicious breakfast made by Susannah when Samuel heard rustling outside followed by his hunting dog barking. Immediately, he grabbed his rifle, ran to the door and went outside to see what animal the dog had treed. While Samuel was in a hurry to see what his dog had caught, Susannah and her small sons—Joseph, age five, and George, age six—stayed behind and finished their breakfast. After they were done eating, Susannah gathered the dirty dishes and began to do her daily household chores, while caring for her two-year-old daughter. Preoccupied with other things, Susannah lost track of her boys, and they wandered out of the house and into the woods. It is thought they went out to follow their father.

Several hours passed, and Samuel was still outside hunting, unable to find what his dog was barking at. Susannah remained busy with household chores. When Samuel returned to the family cabin, he and Susannah realized that their boys were missing. Susannah thought that maybe the

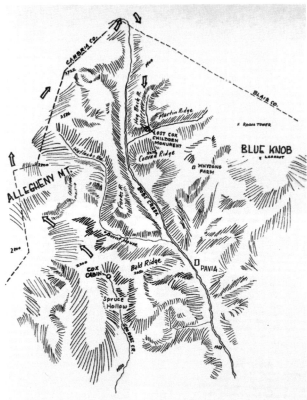

Above: This depiction of Susannah and Samuel Cox, parents of the Lost Children of the Alleghenies, hangs in the Bedford County Historical Society. *Courtesy of Joe McAndrew.*

Left: A map of the area around Pavia and Blue Knob where the search for the Lost Children took place. The route that the children are suspected to have taken is depicted with arrows. *Courtesy of the Bedford County Historical Society.*

boys were helping their dad, but Samuel had no idea that they had even left the cabin to begin with. Extreme panic set in, and the parents ran into the woods, searching everywhere and anywhere for Joseph and George. More time passed, and Samuel and Susannah soon realized that their boys were gone. The sun was beginning to set on that cold April day, and Samuel desperately wanted to find his boys before nightfall because he was afraid of what the wilderness held for them after dark. Samuel knew that with the bitter cold weather, he would need all the assistance he could find to help look for his boys.

Word about the missing boys spread quickly, and people from all over came to help Samuel and Susannah look for their sons. Immediate neighbors, as well as people from Bedford, Blair and Cambria Counties, joined the search. Surprisingly, in the days that followed, people from as far away as Pittsburgh heard the news and traveled to Spruce Hollow to search for the missing boys. Almost two weeks went by, and thousands of people had gathered to the area of Blue Knob to scour the countryside. They searched all of the woods surrounding the Cox cabin in hopes of finding the boys before it was too late. As time passed with no success, searchers became disheartened, and rumors about the missing boys began to spread. Some felt that Joseph and George were murdered by the parents, killed by a man-eating beast or drowned. In desperation, some of the men thought that they should seek supernatural help from the local witch, Moll Wampler.

Moll Wampler lived alone in the mountains, and the locals rarely associated with her because she was perceived as being evil and associating with the devil. However, some of the men thought it was a good idea to have Moll Wampler help because she could use her *Erdspiegel*, which literally translates from German into English as earth-mirror. The *Erdspiegel* was an instrument that Moll used to look into the past, present, and future, and the searchers hoped that she would be able to use it to help find Joseph and George. Others felt it was a bad idea to involve her in the search because her practices were that of the devil. Despite their hesitation, some of the searchers decided to pay Moll Wampler a visit.

When the men arrived at the witch's house and knocked on the door, she told them to enter in an irritated tone. She then removed the *Erdspiegel* from her bosom (where it was stored for safekeeping) and placed it in the bottom of a black bag. She then proceeded to glare over the bag, and eventually, she said she saw the children. In order to confirm that she indeed did see the children, she described them and what she saw. The witch said:

*On this hyur mountain…they's a-layin on the ground—I see just whur
they is—jes whur you be to go to git 'em—they's a layin right a-side a stone
an'a clump ov laurel—they's under a lot of chestnut an' rockoak trees—I
dunno if they's alive or sleepin'—they's a-layin' mighty still—I see whur
they's been a'chawin' mountain-tea berries—they's a livin', I jedge.*

The vision seen by Moll in her *Erdspiegel* seemed to put some of the missing
pieces together and gave the men hope that they could possibly find the missing
boys. Moll Wampler told the men exactly where the *Erdspiegel* showed her the
boys would be, but sadly the men were unable to find them at the location.
They were forced to carry on with their search without magical help.

At this point, the searchers were becoming irritable and losing hope that
they would ever find a trace of Joseph and George. One of them, a young
farmer by the name of Jacob Dibert, was so worked up about the missing
boys that he began to have dreams about them. Dibert was a man who was
known to have vivid dreams that often came true. For three nights in a row,
he had the same horrifying but realistic dream about the missing boys. Jacob
dreamed that he was out searching for the boys when he saw a dead deer.
He walked past the deer and found a little boy's shoe. He continued to walk
a little farther until he came to a little creek. He followed it upstream for a
while and saw an old tree standing in the water. As he walked to the tree,
he noticed the bodies of Joseph and George Cox curled up in the roots of
the tree. Jacob was so disturbed by the dream that at first he only told his
wife, but he soon knew that he had to take action. They decided that it was
best to tell Jacob's brother-in-law, Harrison Whysong, who was from Pavia
and was very familiar with the area in which the boys went missing. At first,
when Jacob approached Harrison and told him about the dream, Harrison
was hesitant and skeptical, but he agreed to help Jacob look for the boys.
Harrison knew exactly where Jacob was talking about in his dream, and on
May 8, 1856, the two men began their hunt for George and Joseph Cox.

Harrison took Jacob to the exact place he described in his dream, and
soon it became all too real. Shortly after they entered the woods, they found
a deer carcass and then the little boy's shoe. After walking a ways down, they
came across a creek and followed it upstream, where they eventually saw a
large old tree standing. Both Harrison and Jacob stood in pure shock and
fear as to what lay ahead. The stared at the tree for a period of time until
they gathered enough nerve to walk closer. As they walked closer to the tree,
the two men could see in the roots the two small bodies of the boys huddled
together, as if frozen from fear and trying to keep each other warm. It is

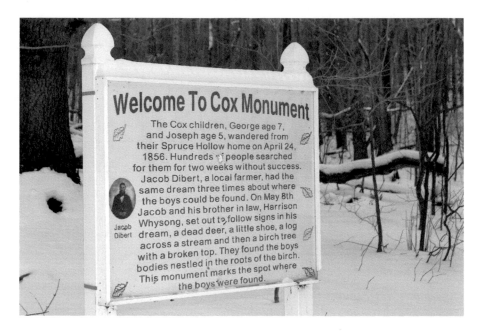

The sign at the Cox Monument telling the story of the boys and of Jacob Dibert's dream. *Courtesy of Joe McAndrew.*

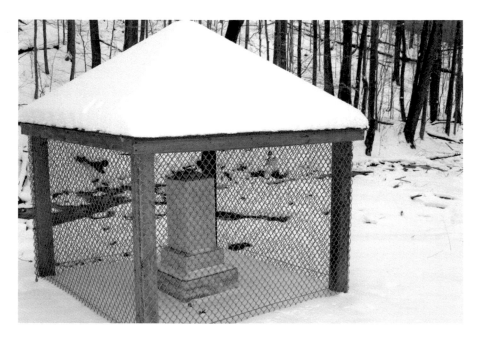

The Cox Monument marks the spot where the Lost Children were discovered. It is now surrounded by a protective structure because of vandalism. *Courtesy of Joe McAndrew.*

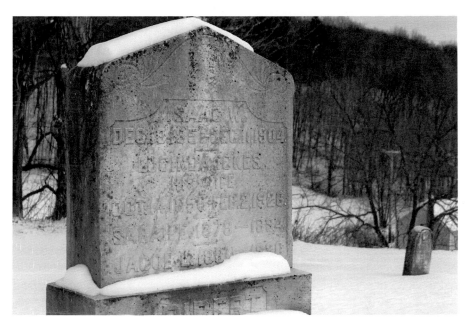

Jacob Dibert's grave. *Courtesy of Joseph McAndrew.*

Jacob Dibert is buried at the Mt. Zion Reformed Church and Cemetery. *Courtesy of Joe McAndrew.*

believed that the boys were dead for four days before they were found, the night that Jacob had his first dream. Harrison and Jacob were in disbelief as to what had just happened, but they knew that they had to immediately return the boys to their parents in Spruce Hollow. Church and school bells tolled in Pavia and the surrounding areas once the boys' bodies were found. Dibert and Whysong were soon seen as heroes to many, but others questioned the men as to how they knew exactly where the boys' bodies were. Some wondered if it was at all possible that Jacob Dibert murdered the little Cox boys or left them in the blistering cold to die.

A few days after George and Joseph's bodies were found, a funeral was held in a little church in Spruce Hollow, and they were laid to rest in a single grave in the cemetery behind the church. Fifty years after the Cox boys' bodies were found, a monument was erected in remembrance of their tragic deaths. The monument is located in the exact spot where the boys were discovered. The tale of the Lost Children of the Alleghenies is a great tragedy that affected the people of Pavia and the surrounding area. The monument is a constant reminder of how the people were touched by such an unfortunate and mysterious incident that continues to perplex those who read about the boys who went missing on that cold and snowy April morning in 1856.

SOURCES

Bedford Area School District. "Lost Children of the Alleghenies (The Cox Children)." http://www.bedford.k12.pa.us/c12/history%20of%20 bedford/lostchildrenalleghenies.htm.

Dibert, Don. "Lost Children of the Alleghenies." Pennsylvania Mountains of Attractions. http://www.pennsylvania-mountains-of-attractions.com/ lost-children-of-the-alleghenies.

Frear, Ned. *The Lost Children*. Bedford, PA: Frear Publications, 2002.

"Map of Pavia 1877." In *Historical Maps of Bedford & Fulton Counties, Pennsylvania*. Bedford, PA: Windmill, 1878.

McCarthy, Charles R. *The Lost Children of the Alleghenies and How They Were Found through a Dream*. Huntingdon, PA: Brethren's Publishing Co., 1888.

Swetnam, George. *Devils, Ghosts, and Witches: Occult Folklore of the Upper Ohio Valley: An Anthology*. Greensburg, PA: McDonald/Swärd Pub., 1988.

Wilson, Patty. "Lost Children of the Alleghenies." http://media.wix.com/ ugd/29a4c4_4c53875f872ce1dea2526d37f8c3b3c3.pdf.

A PRACTITIONER
EXPLAINS POWWOW

Rob Chapman

The rolling hills and farmlands of south-central and southeastern Pennsylvania are locally referred to as "Pennsylvania Dutch Country," due to the waves of immigration, primarily in the seventeenth and eighteenth centuries, of folk from Switzerland, Austria, Alsace and the Palatinate area of Germany who were united in their common dialect: *Dietsch* or German. Those early settlers were of various religious persuasions, including Mennonite, Amish, German Reformed, Lutheran and Catholic, and most came here seeking freedom to live as they wished to live and worship as they wished to worship. The appeal of William Penn's plan for a haven of religious tolerance and freedom was especially attractive, as was the promise of fertile soil and prosperity.

In addition to the diverse religious beliefs of the people who would be collectively known as the Pennsylvania Dutch (who established the Lutheran and Reformed churches as well as the Moravian church and the Anabaptist sects), they also brought with them a rich lore of superstition, home remedies, holiday traditions and family values. These traditions and practices would eventually become influential in establishing many of our iconic American images: decorated barns, the Amish horse and buggy, German *fraktur* art and colorful hex signs, to name but a few.

One of the more obscure traditions brought to America by those early settlers was the practice of *brauche*, or *using*. This was the folk magic and faith-healing practice of the German-speaking people and would quickly become integrated into American folklore as the tradition of "powwowing."

This photograph from the early twentieth century shows a distinctive Pennsylvania Dutch barn in Lehigh County. *Courtesy of the Library of Congress.*

Powwowing involves the laying on of hands, the repetition of spoken words and Christian prayers to call on the power of the Holy Trinity and the creation of written charms for the express purposes of healing, protection and solving other needs of the day, such as mending broken glass or freeing a horse from the powers of witchcraft. Powwowing draws its power from both the Old and New Testaments and is believed by many of its practitioners to be a reflection of the biblical mandate of Christ as recorded in Mark 16: "In my name they will drive out demons...they will place their hands on sick people, and they will get well." Or as recorded in Psalm 50: "call upon me in the day of trouble; I will deliver you, and you will honor me."

Much of the *brauche* tradition was rather simple and passed on through families as just another aspect of living, similar to family recipes or religious traditions. It was not until the early 1800s, with the publication of *The Long Hidden Friend* by John George Hohman of Reading, Pennsylvania, that we would have an American grimoire that gathered the various magical workings

of the *brauche* tradition (or *braucherei*) together in one place. This publication was an instant success and quickly became a popular book in many Pennsylvania German homes, with popularity almost equal to the family Bible. *The Long Hidden Friend* (or *Long Lost Friend*, depending on the edition), with its straightforward presentation of the most popular *brauche* charms, has been in almost continuous publication in Pennsylvania for nearly two hundred years. It was during one of its many republishings that the book was dubbed *"Pow wows,"* either as a slur by the English or to somehow give it a connection to Native American practices, of which it has none. Whatever the reasoning behind calling the book *"Pow wows,"* the name stuck, and the original usage of the word *brauche* fell out of popularity. Today, the

Der lange

Verborgene Freund,

oder:

Getreuer und Christlicher

Unterricht für jedermann,

enthaltend:

Wunderbare und probmäßige

Mittel und Künste,

Sowohl für die Menschen als das Vieh.

Mit vielen Zeugen bewiesen in diesem Buch, und wovon das Mehrste noch wenig bekannt ist, und zum allerersten Mal in America im Druck erscheint.

———

Herausgegeben
von

Johann Georg Hohman,
Nahe bey Reading, in Elsaß Taunschip, Berks County, Pennsylvanien.

Reading:
Gedruckt für den Verfasser.
1820.

The title page of the original 1820 German language edition of *The Long Hidden Friend* (also known as *The Long Lost Friend*) by John George Hohman. *Editor's collection.*

tradition is known as powwowing, and its practitioners are called powwows. Since the publication of *The Long Hidden Friend,* more grimoires have surfaced, many of them being small publications, probably for use within specific families. Most of them are variations on the charms found within Hohman's work.

Powwowing is considered something of a cultural oddity when viewed from outside the Pennsylvania German culture, and indeed, it didn't really spread too far from its original home here in Pennsylvania. Most who hear or read of powwowing see it as a remnant of a long-forgotten past or the traditions of the superstitious and less educated. However, the popularity of

the powwowing tradition and the respect it holds among the Pennsylvania German community makes the tradition an important piece of the culture that is worth preserving.

Most of the charms used within the powwowing tradition are reminiscent of medieval anti-witchcraft charms utilized by the Catholic Church. Some are snippets of biblical verse, while others are colorful narratives that have religious tone but were written with obvious creative license. An example of a typical healing charm for the curing of headache: "Tame thou flesh and bone like Christ in Paradise; and who will assist thee, this I tell thee (name) for your repentance sake."

This charm would have been spoken three times to effect relief, with the client's full baptismal name spoken. If relief was not immediate, it would have been repeated three more times, and more as needed. Most of the spoken charms in powwowing are to be repeated at least three times and done so in the names of "the Father, the Son, and the Holy Ghost." In some sources, there are directions to follow up the spoken charms with the recitation of the Pater Noster (Our Father), Ave Maria and the Creed. Here is an example of a spoken charm from *The Long Lost Friend* used to "fasten or spell-bind anything": "Christ's cross and Christ's crown, Christ Jesus' colored blood, be thou every hour good. God the Father is before me; God the Son is beside me; God the Holy Ghost is behind me. Whoever now is stronger than these three persons may come, by day or night, to attack me."

Then powwowwers would say the Lord's Prayer three times.

Here is an example of a common hand-written charm to be carried for protection:

I.
N. I. R.
I.
SANCTUS SPIRITUS
I.
N. I. R.
I.

All this be guarded here in time and there in eternity. Amen.

Many of the charms, such as the one following, seem to make little sense. Yet the Christian symbolism is present, and the power is believed

to be not so much in the words themselves but in the images they convey and the powers they call on. A spoken charm against swellings goes like this: "Three pure virgins went out on a journey to inspect a swelling and sickness. The first one said, 'It is hoarse.' The second said, 'It is not.' The third said, 'If it is not, then will our Lord Jesus Christ come.' This must be spoken in the name of the Holy Trinity."

The practitioner of powwow would not charge for his services but would be known to accept donations of food or money whenever offered. The power to heal was believed to be God-given, and thus it was considered taboo to charge for healing work.

There were very few tools or props used in the powwow tradition. The only constant among all practitioners was the presence of the Bible during a healing session. Some would read from the Bible, while others would place their hands on it or instruct their clients to hold on to it during the healing work. Still others didn't touch the Bible at all during a healing, merely keeping it present as a talisman of sorts to further bless their work.

The powwowing tradition had enjoyed almost continuous adherence among the Pennsylvania Germans until the late 1920s when the murder of powwower Nelson Rhemeyer cast a national and unfavorable spotlight on the practice. From that point forward, the tradition lost much of its cultural respect and went largely underground, being practiced mostly in secret or suppressed entirely. For some families, it became a taboo subject altogether. It was not until the latter part of the twentieth century and early twenty-first century, with works by historians such as David Kriebel and the Pennsylvania German Society, that powwowing would once again be recognized as an important piece of the Pennsylvania German culture.

Today, there are only a small handful of practitioners of the powwowing tradition who are preserving the practice in a manner that would be recognized by our cultural ancestors. While there may be small differences in our methods of practice, the common threads that bind us together are our shared cultural ancestry, our strong Christian faith and our love for our cultural traditions. Indeed, to practice powwow today means to preserve a piece of a culture that is threatened by the encroachment of modern living and development and to honor the faith of our ancestors that was a vital part of their lifestyles and the inspiration for their migration to America.

SOURCES

Berks County Historical Society. www.berkshistory.org.

Bilardi, Chris R. *The Red Church or The Art of Pennsylvania German Braucherei.* Sunland, CA: Pendraig Publishing, 2009.

Chapman, Rob. *"Pennsylvania Dutch Powwow."* www.braucher.webs.com.

Historical Society of Pennsylvania. "Exploring Diversity in Pennsylvania History." www.hsp.org.

Hoffman, W.J., MD. *Folk-Medicine of the Pennsylvania Germans.* N.p.: American Philosophical Society, 1889.

The Holy Bible, New International Version. N.p.: International Bible Society, 1984.

Kriebel, David. *Powwowing Among the Pennsylvania Dutch: A Traditional Medical Practice in the Modern World.* University Park: Penn State University Press, 2008.

"The Long Hidden Friend." *Journal of American Folklore* 17, no. 65 (April–June 1904): 89–152.

McGinnis, J. Ross. *Trials of Hex.* York, PA: Davis/Trinity Publishing, 2000.

Pennsylvania German Society. www.pgs.org.

Reed, Terry. "The Secret Healers." *Reading Eagle*, May 9, 2013.

"Set Apart: Religious Communities in Pennsylvania." www.explorepahistory. com.

White, Thomas. *Witches of Pennsylvania: Occult History and Lore.* Charleston, SC: The History Press, 2013.

LETTERS FROM HEAVEN

Katherine Barbera

C harms and wards are nearly ubiquitous in folk religion. Some examples are verbal and some are material, but they all operate under the same basic premise: they prevent bad events or cause good events. In German and German-American folklore, one unique example is the *Himmelsbrief,* or "letter from Heaven."

According to the tradition, *Himmelsbriefs,* also sometimes written *Himmels Briefs,* are letters written by Jesus. Most often, they contain passages from scripture, moral messages and prayers. Sometimes, the letters also contain explanations for their origin. One of the earliest letters claims that the Angel Gabriel delivered it from heaven to a church in Germany. Before World War II, these letters were commonplace in Germany, but they were also found frequently in the homes of the Pennsylvania Dutch. As German immigrants flooded the United States, *Himmelsbriefs* became part of American folk religion.

Like many other folk beliefs, the exact origins of the *Himmelsbrief* are unknown, but many folklorists date the earliest letters to the sixteenth century. At first, the letters were handwritten, but soon after, they were reproduced in broadside or one-sided prints. In the United States, the Pennsylvania Dutch would frame the letters and hang them in their homes. They warded off lawsuits, sickness, disasters and general harm. During wartime, Pennsylvania Dutch soldiers also carried them into battle.

There are many different versions of *Himmelsbriefs,* but the letters often preach similar messages and contain similar passages. A translation of one

An example of a common *Himmelsbrief* that circulated in Pennsylvania during the 1800s. *Editor's collection.*

of the more widespread letters appeared in a 1908 issue of the *Pennsylvania-German.* The Letter of St. Germain tells its reader, "Thus I command you, that on Sunday ye do no work on your estate nor any other work, but that ye diligently go to church and pray devoutly. Ye shall not curl your hair nor practice the vanities of the world, and of your wealth ye shall give to the poor." In this case, the letter called its reader to go to church on Sunday and obey the Sabbath. Many *Himmelsbriefs* contain similar habitual Christian teachings.

The *Himmelsbrief* is just one of many practices in German folk religion. Twentieth-century Pennsylvania folklorist Edwin M. Fogel noted the complementary nature of the German folk healing practice of powwow and the *Himmelsbrief.* In 1908, he wrote, "The former is used in a specific case and for the healing of a specific disease; the latter, to escape disease, disaster or the devil." The *Himmelsbrief* is a ward; it is meant to prevent harm. Powwow is a healing practice; it is used after harm is already done.

In more recent years, folklorists have compared the *Himmelsbrief* with other more modern practices. Bill Ellis notes the interesting correlation with chain letters. Like their contemporary cousins, *Himmelsbriefs* requested—or sometimes demanded—that the reader copy and distribute them. In copying the letter, the reader would gain something; in most cases, it was protection from harm. Also like modern chain letters, some *Himmelsbriefs* warned against failing to copy them. If he or she refused, the reader would be cursed. In the example of the Letter of St. Germain, the text is less demanding, but it makes its purpose clear. It reads, "When one tries to grasp the letter it moves away, but when one wishes to copy the same it approaches and spreads itself out." In order to understand the true meaning of the letter, the reader must copy it by hand.

Himmelsbriefs are often long and rarely in English. Below is a full translation of the Letter of Saint Germain.

Which was written in golden letters, and which is to be seen in St. Michael's Church at St. Germain, where it hovers over the baptismal font. When one tries to grasp the letter it moves away, but when one wishes to copy the same it approaches and spreads itself out. In this way it has been distributed all over the world. Teach me that I keep my commandments. Give to me, my son, thy heart. Thus I command you, that on Sunday ye do no work on your estate nor any other work, but that ye diligently go to church and pray devoutly. Ye shall not curl your hair nor practice the vanities of the world, and of your wealth ye shall give to the poor. And divine hand has been sent out by Jesus Christ; and ye shall not act like irrational beasts. I have given you six days in which to perform your work, and on Sunday ye shall early proceed to church to hear the holy sermon and listen to God's word. If ye will not do this I will punish ye with Pestilence, War and Hard Times. I command you that on Saturdays ye labor not late, and that on Sundays ye go to church early with others, young and old, and there devoutly ask and pray that your sins be forgiven you. Swear not in anger by my name, covet not silver and gold, and yearn not after fleshly lusts and desires. As easily as I created you, so suddenly can I destroy you. No one shall kill another, and with your tongues be not false to your neighbors behind their backs. Rejoice not in your riches. Honor your father and mother; speak not with false witness against, your neighbors and I will give you health and peace. Whoever believeth not this letter and regulateth not his conduct by it, shall have neither luck nor blessing. This letter shall be copied by one for another, and if you do this, be your sins as many fold as the sands on the seashore, as numerous as the leaves of the forest, or the stars in the heavens, they shall be forgiven you. Believe wholly what this letter says and teaches you, for whoever doth not believe it shall die. Repent of your sins or else ye will be eternally tormented, and I shall ask ye on the Judgment Day concerning your sins and you will have to answer. Whoever has this letter in his house or whoever carries it on his person, shall not suffer damage by lightning, and it will protect him from fire and water. The married woman who carries this letter with her shall bear happy and handsome children. Keep my commandments which I have sent to you through my angel Gabriel. A beautiful Christian Prayer to be used at all hours: O, Father Son and Spirit, in essence One Three-fold in name, to thee, and thee alone. My heart in love and adoration swells, O God, whose joy above in heaven dwells.

Like powwowing, *Himmelsbriefs* persist in the twenty-first century. They are still found in Pennsylvania Dutch homes throughout Pennsylvania. Next time you are in the state, keep a watch out for large ornate prints in German. If you see one, you may have just found a letter from Heaven.

SOURCES

Ellis, Bill. *Lucifer Ascending: The Occult in Folklore and Popular Culture*. Lexington: University Press of Kentucky, 2004.

Fogel, Edwin M. "The Himmelsbrief." *German American Annals* 6 (1908): 286–311.

Yoder, Don. *Discovering American Folklife: Essays on Folk Culture and the Pennsylvania Dutch*. Mechanicsburg, PA: Stackpole Books, 2001.

INDEX

ABOUT THE CONTRIBUTORS

KATHERINE BARBERA has a master's degree in history from Duquesne University. She focuses on public history, and her research centers around religion and labor in the United States in the twentieth century.

MICHELLE BERTONI has her bachelor's in history from La Roche College and her master's in education from Carlow University. She has a passion for history and enjoys uncovering the mysteries associated with it. Contributing to this book about the supernatural legends of Pennsylvania has been an inspiring adventure and has further piqued her curiosity about the unique history of Pennsylvania.

STEPHEN A. BOSNYAK developed an interest in the unknown at a very early age. The discovery of the books by Daniel Cohen in an elementary school's library only helped to fuel that curiosity. Through the years, Bosnyak has focused more of his attention toward researching local folklore and urban legends. Currently, he is the administrator for a website that showcases one of Allegheny County's strangest places: Dead Man's Hollow (http://www. dead-mans-hollow.com/).

CANDICE BUCHANAN works as a board-certified genealogist and an archivist for Memory Medallion, Inc. She initiated and continues to lead the Greene County, Pennsylvania Archives Project, a local history website at www. GreeneConnections.com focused on the digitization and preservation of

original photographs and documents for public access. Candice obtained her bachelor's degree in history from Waynesburg University and her master's degree in public history from Duquesne University.

ROB CHAPMAN lives in South-Central Pennsylvania and has a passion for Pennsylvania German folklore and history. His ancestry is a blend of Austrian, English and Irish, and he can trace his family as far back as the early 1700s. In addition to Pennsylvania German folklore, Rob studies astrology and Christian history and has a love for all things sci-fi and fantasy. He lectures on Pennsylvania German folk magic and faith healing at universities, colleges and other venues and shares much of what he learns on his website, www.braucher.webs.com. He lives in Cumberland County with his partner, Bill, and their two dogs.

RACHAEL GERSTEIN is a native of northeastern Pennsylvania with an interest in unexplained phenomena and Pennsylvania legends. She is currently working toward a pharmacy degree at the Mylan School of Pharmacy at Duquesne University.

STEPHANIE HOOVER is an author and researcher specializing in historical mysteries and true crime. She is the author of *The Killing of John Sharpless* and *Philadelphia Spiritualism and the Curious Case of Katie King*. Visit www.StephanieHoover.com for details.

TONY LAVORGNE is an independent researcher of historical mysteries and the paranormal. A native of Pittsburgh, he has a degree in both photography and graphic arts. He also runs his own antique business called My Generation Collectibles.

GERARD O'NEIL has lived in the Pittsburgh area for over twenty years and has a master of arts in public history from Duquesne University, where he currently works in the archives. He is also an adjunct professor of English at La Roche College and provides sound systems for numerous cultural events in the Pittsburgh area. He specializes in obscure, esoteric and unusual historical and anthropological topics.

ROBIN SWOPE has been a protestant minister for over twenty years, serving in mainline and evangelical churches. He has a bachelor of arts in biblical literature and a master's of divinity in pastoral ministry. Currently, Reverend

Swope is the pastor of St. Paul's United Church of Christ in downtown Erie, Pennsylvania. He is an author and seminary-trained exorcist who has done consulting work for television productions and paranormal groups worldwide. His blog "The Paranormal Pastor" (http://theparanormalpastor.blogspot.com/) looks at all things supernatural with a unique Christian perspective.

EDWARD WHITE is an attorney in Philadelphia. Edward received his juris doctorate from Villanova University School of Law and a bachelor of arts in history from Saint Vincent College. He has resided in the Philadelphia area since 1999. He previously teamed up with his brother Thomas in writing *Forgotten Tales of Philadelphia* in 2010.

ELIZABETH WILLIAMS-HERRMAN is the college archivist at La Roche College, where she earned her bachelor's degree in history in 2007. She also holds a master's degree in public history from Duquesne University. Williams-Herrman is the author of *Pittsburgh in World War I: The Arsenal of the Allies*, published by The History Press in October 2013.

ABOUT THE EDITOR

Thomas White is the university archivist and curator of special collections in the Gumberg Library at Duquesne University. He is also an adjunct lecturer in Duquesne's History Department and an adjunct professor of history at La Roche College. White received a master's degree in public history from Duquesne University. Besides the folklore and history of Pennsylvania, his areas of interest include public history and American cultural history. He is the award-winning author of eight other books, including *Legends and Lore of Western Pennsylvania*, *Forgotten Tales of Pennsylvania*, *Ghosts of Southwestern Pennsylvania*, *Forgotten Tales of Pittsburgh*, *Forgotten Tales of Philadelphia* (co-authored with Edward White), *Gangs and Outlaws of Western Pennsylvania* (co-authored with Michael Hassett), *A Higher Perspective: 100 Years of Business Education at Duquesne University* and *Witches of Pennsylvania: Occult History and Lore*.